Clayton James

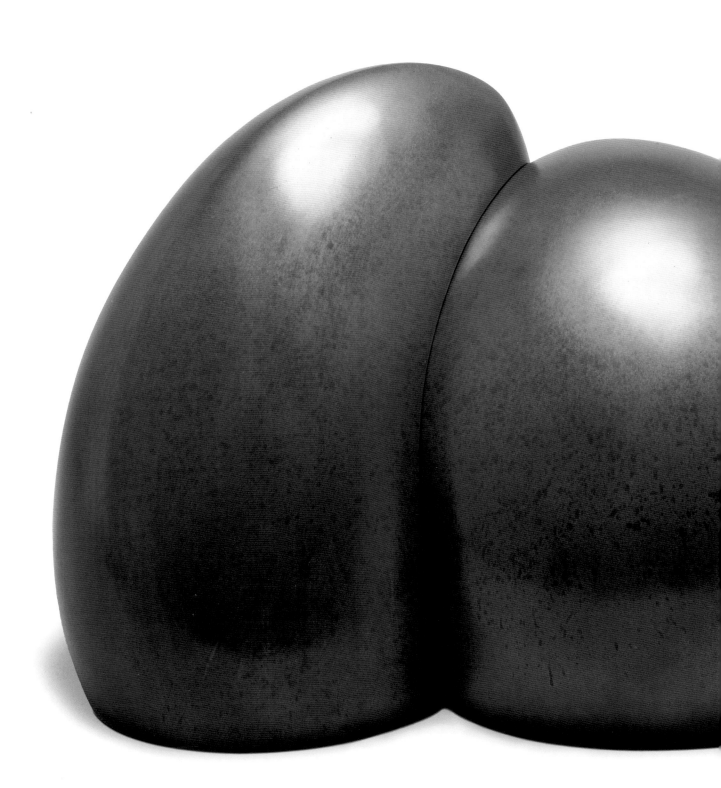

Vicki Halper

Clayton James

Museum *of* Northwest Art, La Conner, Washington
in association with
University of Washington Press, Seattle and London

Clayton James was organized by the Museum of Northwest Art.

This publication accompanied an exhibition of the same title presented at the Museum of Northwest Art, July 13–October 6, 2002.

Published by the Museum of Northwest Art, La Conner, Washington.

Distributed by the University of Washington Press, P.O. Box 50096, Seattle, WA 98145

Library of Congress Control Number: 2002102187
ISBN: 0-295-98264-0

Front cover: detail, *Grand Kiva,* 1980 (cat. 33)
Back cover: Clayton James, 1970. Photo by Arnold Pearson
Frontispiece: *Ancient Mounds,* 1986 (cat. 45)
Page 6: detail, *Black Rock,* ca. 1980 (cat. 29)
Page 8: *Quail,* 1981 (cat. 37)
Page 26: detail, *Klee Moon,* 1988 (cat. 50)
Page 78: James signing pot, 1979. Photo by Mary Randlett

Designed by John Hubbard
Edited by Patricia Kiyono
Principal photography by Eduardo Calderón
Color separations by iocolor, Seattle
Produced by Marquand Books, Inc., Seattle
Printed and bound by CS Graphics Pte., Ltd., Singapore

Contents

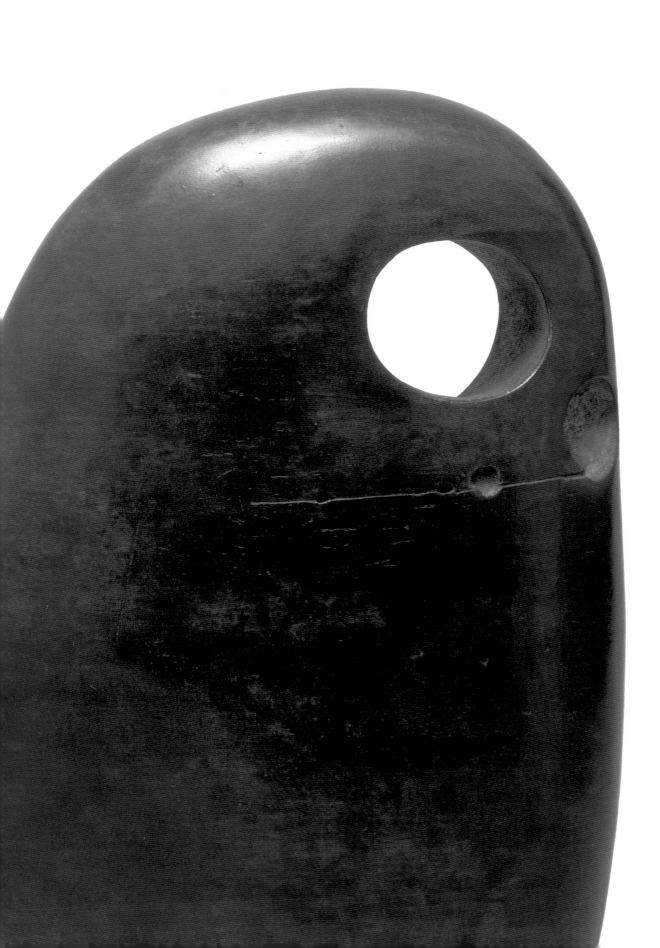

Foreword

Undeterred by finances or convention, Clayton James over the past sixty years has produced significant bodies of work in many media that place him with the foremost artists of the Pacific Northwest today. With great pleasure the Museum of Northwest Art presents this exhibition and catalog chronicling James's career.

I saw Clayton James's sculpture at the Janet Huston Gallery in La Conner, Washington, well before I met the artist. The show evoked a deep response and prompted me to collect beach rocks for my home garden. Beach outings became searches for "Clayton James rocks," abstract forms that expressed so well the essence of nature modified by wind and water. When Clayton and I became friends, I learned that such natural objects had indeed inspired much of his work.

The museum is grateful to the key people who assisted with this project. Exhibition curator Vicki Halper thanks Clayton James for gracefully submitting to prolonged scrutiny, and she is indebted to Barbara James for her inestimable skills as chief curator at MoNA and keeper of Clayton's records. She also thanks those who spoke with her at length about James: Rich Conover, Jeff Day, La Mar Harrington, Paul Havas, Elaine Jorgensen, Hans Jorgensen, Charles Krafft, Mary Randlett, and Ken Stevens. I join Vicki in gratefully acknowledging the lenders listed in the catalog and those collectors whose willingness to lend works could not be accommodated.

The Clayton James project received generous support from the Allen Foundation for the Arts, the Washington State Arts Commission, the MoNA Board of Trustees, and private individuals. The museum is honored to bring Clayton James's work to a wider audience.

Susan Parke
Executive Director

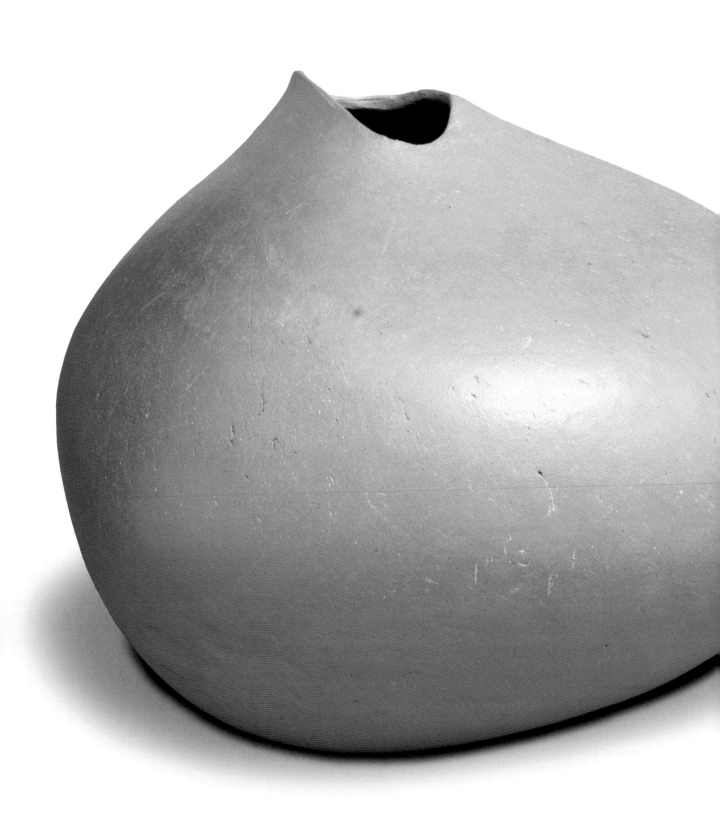

Clayton James

Clayton James traveled to the Pacific Northwest involuntarily when he was twenty-six years old and then stayed by choice. As a conscientious objector to World War II, he was shipped to a camp on the then-remote Oregon coast, where he first saw conifer forests and great blue herons. After the war he eventually settled in the Skagit Valley, a flat, fertile area of coastal Washington State known for its fields of cultivated tulips and for artists like James who have lived there—artists gripped by nature and scornful of wealth, whose simple lifestyles seem as much a moral imperative as a financial necessity. There in La Conner, living in the early 1900s house he has shared with his wife for half a century, and working in the old studio building across the road for almost as long, James has created sculptures and vessels of cement, wood, and clay, and completed the plein air paintings of recent years. The best of these works display an authority and subtlety that can make one weep.

Preamble

James was drafted in 1942, his last year at the Rhode Island School of Design (RISD). The art department was dominated by the Provincetown School of landscape painters, a conservative group in the tradition of American impressionist William Merritt Chase and his student Charles Webster Hawthorne. In summer school classes led by RISD professors on the tip of Cape Cod, students painted outdoors (en plein air), creating beach scenes and seascapes that defied time and ignored the stirrings of the abstract expressionist movement evident in Hans Hofmann's revolutionary classroom a short distance away.

James, a serious young man with a Greek profile and a strict Methodist upbringing, was un-interested in Hofmann's painterly innovations. He attended John Frazier's traditional summer classes in Provincetown between 1939 and 1941 and there became close to Barbara Straker, a RISD student in the class ahead whom he would marry in 1944. After James was drafted, the two of them visited *Americans 1942,* an exhibition at the Museum of Modern Art in New York that contained thirty paintings by the Northwest artist Morris Graves. These paintings were neither realistic landscapes nor brilliant abstractions, but small, reflective works in which birds, sometimes blind or singing, became symbols of the human condition. Graves spoke of the "inner eye" through which one seeks spiritual enlightenment and depicted that ecstatic state with skeins of white lines that surrounded or enmeshed birds with light. His symbolic approach to painting, focused on his yearning for insight into ultimate

Clayton James in his studio at the camp for conscientious objectors, Big Flats, New York, winter 1942–43.

matters of the soul, was profoundly attractive to James, as was the work of older symbolists such as William Blake and Odilon Redon. Graves, more-over, was a pacifist like James. When he refused induction into the army in April 1942, he was held for months in a stockade and then placed in general army quarters for the remainder of the year.[1] When James arrived on the West Coast in 1944, he wrote to Graves, who had returned to his secluded Washington home, and invited him to visit the camp for conscientious objectors in Waldport, Oregon.

Oregon was James's fifth stop as a CO. He had already spent almost three years in similar camps for alternative service run by established pacifist

Barbara and Clayton James, Waldport, Oregon, 1944.

religious groups like the Quakers and the Church of the Brethren. In Petersham, Massachusetts, James dug water holes and tried to paint; in Big Flats, New York, he worked as a cook and tried to paint; and in Concord, New Hampshire, he worked in a mental hospital and tried to paint. When James refused to modify his schedule as required by the hospital (he wanted to continue laboring at night and painting in the daylight), he was returned to Big Flats, where he worked as a night watchman, set up a studio, painted under the influence of El Greco and Blake, and discussed the meaning of life with others engaged in personal searches. In 1944, when James was allowed to choose between a camp in Florida and one in Oregon,

Barbara urged him to go to the Northwest, whose natural beauty she knew of from photographs. In addition, the camp there was noted for its extra-curricular art activities, particularly its publications of poetry from the Untide Press. "They were glad to get rid of me at Big Flats," says James, a stubborn man who takes unkindly to direction.[2]

> I came out on the train with another war objector. We got off in Corvallis and had to hitchhike to get to camp. We walked a lot of the way. And I was really amazed, coming from New England where everything was gnarled and runty. Here were these beautiful big trees and skunk cabbages this tall. It was like open-ing up a whole world. And the ocean was so strong and so powerful that I couldn't paint. My paintings became zero. This was also a result of my religious fervor.

Camp Angel in Waldport was beside the Pacific Ocean. Across the road from the camp, on a bluff above the beach, empty tourist cabins served as studios to CO artists and homes to their families. "It wasn't legal; nobody cared. We were outsiders, outside the norm. The best thing to do was to for-get about us as long as we didn't make any trouble." According to Adrian Wilson, who chronicled life at the camp, the COs there were divided into some-times warring factions—a dorm of liberal artists including poets, musicians, actors, and painters versus a dorm of religious fundamentalists. There were many strong personalities. "COs are anar-chists," Wilson writes, "because they all want the chair but know they haven't got the stuff to be

chairmen." They aspired, he adds, to the "life of non-compromise."[3]

James was in the artists' group by vocation but was more philosophical and less freewheeling than most of the others. Barbara James, who had married Clayton in Oregon and was living in one of the cabins, writes: "Mysticism was very much in the air and of concern to Clayton who was very one-pointed in his focus and did not hang out with the other jazz-listening, wife-swapping artists. Instead, night after night we had long philosophical discussions with the poet William Everson (later Brother Antoninus, then Bill Everson again) who patiently sorted out and helped articulate Clayton's tangled thoughts."[4] James says that he was "trying to formulate a philosophy outside of the Methodist Church" of his youth. "What is the meaning of life? That was the basic thing; that was our big subject matter. What does life mean? Young minds at work." He tried to paint a circle, but failed: "I was seeking perfection in an imperfect world." Barbara adds, "We were searching for the absolute. We tried to reduce everything to one—one solution, one creator, and in Clayton's painting, one simple element or symbol."

Morris Graves accepted the invitation to Camp Angel and arrived in June 1944 "like a savior," in James's words. A tall, beautiful man whose behavior could be aloof, enchanting, or antic, Graves built a shake-roofed lean-to on the border of the forest and beach, which he occupied for two months; he furnished it with exquisite bits of nature combed from the forest and beach. The lean-to was in the spirit of The Rock, the house Graves had built on a cliff overlooking Lake Campbell near Deception Pass in northwestern Washington. Art critic Sheila Farr calls Graves's building style "opulent asceticism": no electricity, no running water, but scavenged objects that were "unfailingly gorgeous." The style influenced every artist who came in contact with it and is reflected in the Jameses' La Conner home today.[5]

Clayton and Barbara visited Graves's home during James's furlough that fall. They returned to The Rock in the spring of 1945 and stayed after James went AWOL. The war was almost over and Camp Angel was falling into disarray. Following in Graves's footsteps, James built a lean-to on Lake Campbell, below Graves's home, and he and Barbara lived in it for a few months. They returned penniless to Waldport at the end of July, relying on the Church of the Brethren to feed them. James built yet another residence in Graves's style, using an old pile of shakes he had split for the pleasure of it when he discovered the wonders of red cedar trees a year before. The Jameses were sitting on the beach in the fog when the war ended in August. Clayton was still AWOL, and the FBI soon arrested him and took him to Portland for trial. "The war was over. I had the trial and I was guilty, but they gave me a suspended sentence. That's the end of the camp experience."

In March 1946 Barbara and Clayton moved to Union, Washington, in the Hood Canal area of Puget Sound as guests of printmaker Waldo Chase, a friend from Camp Angel. As more and more veterans of the camp showed up, James, who doesn't like crowds, constructed a Japanese-teahouse-like building in the woods, open to the weather on three sides. "It was a beautiful thing," James says. "We ate

off the land. We gathered oysters and mushrooms and we had a garden. I wasn't painting; Barbara was trying to paint a little. Life was too confusing to paint. We were just trying to find our way." Wilson recalls that Clayton and Barbara were living in a tee-pee, "raving about the feeling of going up to the mountains: how you lose all the dogmas, find a new pristine self."[6] Barbara remembers that wood mice ate their blankets.

Discovered by the property owner, the Jameses were obligated to move again and spent the winter of 1946–47 in a small house owned by Orre Nobles, a Seattle high school art teacher whose students had included painters Richard Gilkey and James Martin. They ate applesauce, canned milk, and peanut butter, and listened to phonograph records of Bach cello suites. Clayton made leather sandals and sold them for $5 a pair. In the spring Barbara finally left to work in Seattle. "I stayed on a little longer. It's the same old hippie story. But eventually you conform. So I got a job in the Seattle arboretum. That was the end of that chapter of living in nature. It was a great experience."

In Seattle the Jameses were introduced to Vedanta by Graves and his friend Dorothy Schumacher. A universalist branch of Hinduism, Vedanta posits an eternal, infinite "oneness" that encompasses all existence. What Westerners might categorize as the good and the bad, or the high and the lowly, are in Vedanta part of the same oneness. "We became disciples," James says. "We went every week for a couple of years. Christianity doesn't resolve the origin of life, or the meaning of life. Vedanta gave much better answers. It helped

me a lot. So I could relax. All these problems had been with me for *years*. So I could relax."

By 1948 Clayton and Barbara were ready to leave the city and settle permanently. After house-sitting for Morris Graves, in 1949 they bought two acres of land adjoining his property in Woodway Park, Edmonds, just north of Seattle, using money borrowed from Barbara's grandfather. "Morris had bought ten acres and built a low, Japanese-style house out of lumber from an old chicken coop he had torn down," James recalls. "He created a really beautiful little spot. We used to sit out there in the rain at night—Morris wasn't a guy who would go inside, so we all had to sit out there in the rain. And that's where we met the painter Guy Anderson. We became very good friends immediately, and that relationship lasted the rest of Guy's life." Graves abandoned this structure when he claimed, according to Barbara, that he "couldn't get the cackles out."

As Graves was building the imposing main house, which he called Careladen, James dismantled the abandoned structure and moved the lumber across the property line. In constructing his new dwelling, James became greatly frustrated by his incompetence as a builder. Graves suggested he apprentice himself to an old friend, the master woodworker George Nakashima, and wrote a letter of introduction for Clayton. In December 1950 James headed east to New Hope, Pennsylvania, where Nakashima had set up shop after the war. Barbara had already gone east to visit her family in Massachusetts.

An architect turned furniture-maker, Nakashima was world renowned by the time of his death in

1990. He was born in Spokane in 1905 and trained at the University of Washington but had settled in New Hope after his release from the internment camps that imprisoned Japanese Americans during World War II.[7] Nakashima's feelings about wood were quasi-mystical. He believed an ideal form was embedded in each log and board and that finding it would give a second life to inanimate materials: "We work this material to fulfill the yearning of nature to find destiny . . . to release its richness, its beauty, to read its history and life."[8]

James worked for a minimum wage and did piecework at night, turning legs for chairs to supplement their income, while Barbara pursued painting influenced by Graves. On his own, Clayton made furniture and small objects from woodshop scraps. Barbara describes Nakashima as a "perfectionist, samurai warrior, with little patience or sympathy for dummies." After eighteen months of working under this strong figure, James was ready to be on his own again. "George was very upset when I had to leave, but I had to get on with my own life and he got over it. I had an invaluable experience. . . . With the knowledge I gained there, I was able to complete the house in Woodway Park."

Their jeep loaded with chairs, a chest of drawers, and their very first mattress, the Jameses returned to Washington. Clayton worked on his house and took a job with a Seattle cabinetmaker. "I had to get a job. This is one of the things I've always had to do, get a job. . . . But I just couldn't do that work. I was patching up furniture, broken-down cabinets and stuff like that. And I'd been trained by George to do these singular pieces. I was just in misery. So

one day Morris says, 'Let's go up to La Conner and have a picnic.'" A house that the Jameses, Gilkey, Jan Thompson, and other artists had rented as a weekend hangout was empty and Graves knew the owner. The Jameses eventually convinced him to rent them the house, which they still live in today.

In 1953 Clayton and Barbara began to spend their summers working in canneries and painting in La Conner, and their winters earning a living in the Seattle area. That year *Life* magazine published a feature article that identified a regional style of painting in the Pacific Northwest.

Life magazine focused on Mark Tobey, Morris Graves, Guy Anderson, and Kenneth Callahan, artists bound by deep friendships and an interest in Asian philosophy formed during the Great Depression and war years.[9] The article identified a muted, mystical style influenced by the Northwest's rainy climate and proximity to Asia. By the time of publication, however, the friendships had frayed, at least partially from the tensions of fame. Tobey and Graves, the towering figures of Northwest art, had gone their separate ways. Anderson moved to La Conner, where he had lived with Graves in 1937 and where he would eventually produce his best work. His presence in the Skagit Valley, and the brief, terrific impact of Graves's residence, helped turn the valley into a nexus of the Northwest School for a postwar generation of artists.

The Jameses' attachment to La Conner coincided with their detachment from Graves. As he had with Nakashima, Clayton felt the need to separate himself from another strong, demanding personality. Graves was dominating, charismatic, and,

Clayton came to feel, something of a sham at that time. Barbara reports, "When we came to the West, the Graves we met was an antiwar, mystic artist. Now we were dealing with a grandee building a grand house." The cause for the break was Graves's famous "Uninvited Party," one of the Dada-like events for which the artist had been noted since the 1930s. The event was first conceived as a private exhibition for artists who had little outlet for shows in the region, but it was transformed by Graves into a theatrical spectacle in his garden in which the art world powers-that-be were shown the rotting remains of a feast to the sound of squealing pigs. The Jameses were upset to be listed as participants on the invitation without their consent, and to find a coil of barbed wire Graves had placed between his property and theirs to contain the crowds he expected to attend. Their break with Graves was sudden and forceful. A friend of Graves recently noted, "Clayton and Barbara had no madcap in them."[10]

"Morris Graves was a powerful elixir," Barbara says. "The separation was painful and we were isolated in La Conner."

La Conner

In his introduction to the catalog *Skagit Valley Artists,* Tom Robbins describes the broad, flat valley, distant mountain views, and brooding weather: "Despite the thriving bulb industry which frescoes the springtime fields with aggressive Dutch hues, the mood of the Valley is distinctively Chinese." It is "a landscape in a minor key," a "nebulous, very nearly mystic . . . setting."[11] This landscape became the subject matter for James's paintings in the

1950s and again in the 1990s, when he returned almost exclusively to painting after concentrating for decades on three-dimensional forms.

James painted the early La Conner canvases with a palette knife, as Graves had done in the 1930s and Gilkey, in particular, was doing at the time. Few works from this period have survived. In *Untitled (Island Landscape)* (1956, p. 28), James focuses on a cluster of shapes in a broad landscape in which distance and scale are hard to gauge. His low viewpoint, as if he were down in the grass, raises the hillocks of Fir Island to monumental scale. The colors are subdued and the forms minimally shadowed, as on overcast days. The atmosphere has an arid quality, as if the tones but not the moisture of the world outside had affected the painting.

By 1960 James had radically altered his approach to painting under what he might call the pernicious influence of abstract expressionism, the dominant, favored art style of the preceding decade. "Abstract expressionism was in full fling then and you couldn't help but be influenced," James remarks. "But it was the wrong influence for me . . . and I got completely lost and frustrated. . . . My paintings are kind of trumped-up, made-up forms. Just color arrangement. Where the hell are they from?" This negative self-assessment is typically exaggerated or erroneous.

James's abstractions, like *Yellow Night* (1961, p. 30), continue his interest in circles and extend the long history of moon imagery in American visionary painting. Albert Pinkham Ryder, Arthur Dove, and Morris Graves are part of the line. Adolph Gottlieb, the New York School artist whom James credits as his immediate source, painted

flattened disks floating above agitated masses, like a yin-yang of perfection and imperfection, or quiet and discontent. James may see in his own paintings a pale reflection of Gottlieb's circles, but his abstracted night skies are much closer to Graves's yearning, mysterious *Rising Moon* paintings of the early 1940s than to Gottlieb's more clinical, less atmospheric canvases.

James quit painting, frustrated with a style he felt was alien (to be comfortable, he needed the subject matter in front of him, like a landscape), and disgusted with a material, acrylic paint, that he hated. What James calls Part Two of his life began.

James's turn to sculpture was triggered by the presence in the La Conner area of Jim and Nan McKinnell, who in the 1950s and 1960s taught workshops in ceramics at the summer school of Ruth Penington, a University of Washington professor. The McKinnells recognized and encouraged James's natural talent, and he soon built a wheel, dug his own clay, and began producing bowls and cups. James also started to make scale models of sculptures in clay and cast them in cement. Later, after watching Nan demonstrate handbuilding a large pot, James avidly adopted the ancient technique of coiling.

> The McKinnells really changed my life. It just seemed so magical to me that I wanted to work with clay right away. And I had a certain talent. Both Guy and I went down there and tried to throw pots. I wasn't too bad at it. I immediately set up and started throwing pots, and I made a wheel myself (I had to do that) and set it up on the outside of the studio. But I didn't know anything. Technically I was just uninformed. That's the unfortunate part about that period because I really did like working in clay (after all my name is Clayton). I also started three-dimensional work, woodcarving, and some pieces in cement. My whole creative drive was able to find a venue, a way out.

In 1965 the Jameses sold their Woodway property. The income enabled Clayton to leave his job as a landscaper and devote himself fully to art for the first time. A photograph of his La Conner studio in 1970 indicates the volume and diversity of his art during this period. Among other pieces pictured are a ceramic vessel with flared lip and segmented

Nan McKinnell with one of her handbuilt pots, Denver, ca. 1976.

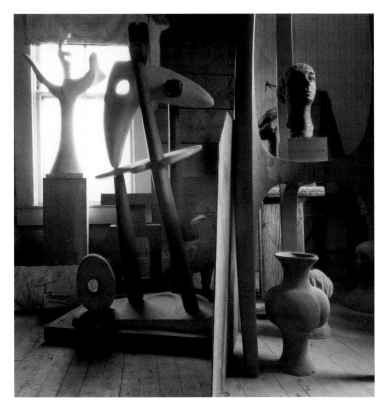

Clayton James's studio in La Conner, Washington, 1970. Photo by Mary Randlett

and *Helmet Head* series (begun in 1950) as well as Etruscan war helmets, which James saw in Italy in 1966 on his only European trip. In Moore's pieces an exterior armor partially encloses an internal form. In the Etruscan works a bronze headpiece is cut out to expose the eyes and the area below the nose, emphasizing positive and negative space. James's helmets of the mid-1970s are closer to the Etruscan ones but are enclosed, more hood-like, and made not of bronze but of clay (or, rarely, cement). They are like upturned vessels with the eyes cut out. The interiors of the pieces are completely hidden, and no allowance is made for a mouth. The heads are ominous and mute. James never realized his desire to create a gigantic antiwar monument from an earlier, more open piece (as Moore had turned a helmet head into a mushroom-cloud-like monument in the University of Chicago's *Nuclear Energy,* 1966).

In 1976–77 the Jameses spent the winter in northern New Mexico. Clayton had intense reactions to the geology and indigenous pottery of the region, and both would have a profound impact on his work. In particular, he saw large Native American storage jars, handbuilt of clay. Rather than concentrate on the surface decoration that made such pieces famous, he focused on their swelling forms; he returned to La Conner with the inspiration that would lead to his most significant body of work. Subject matter had baffled him as a painter of

body, a cement portrait head, and a large construction of wood and cement reminiscent of Isamu Noguchi's sculpture. Other studio photographs taken the same day show a reclining figure of cement that is closely linked to the work of British sculptor Henry Moore and several four- to five-foot-tall twisted leaf forms made of laminated wood, a technical tour de force. James was fifty-two years old but relatively young as a sculptor. His attention to different mediums, artists, and styles was unedited. One can sense both jumble and joy in the studio.

During this period James started a series of head-size sculptures of helmets, antiwar statements for the Vietnam era (p. 36). His sources for the series were Henry Moore's *The Helmet* (1939–40)

abstractions and then seemed to overwhelm him with possibilities in his early sculptures. For a vessel-maker these problems vanished. James stepped surely into an ancient tradition and snapped to attention.

Handbuilding vessels using coils of clay is a slow process compared to throwing. Symmetry, a natural consequence of using a potter's wheel, is difficult to achieve with coiling, if that is your aim. Yet James's 1978 exhibition at the Northwest Crafts Center and Gallery at the Seattle Center showed gorgeously ample and symmetrical pieces, with taut forms in which scraped-rough and burnished-smooth surfaces are meticulously controlled. The pots tend to have either a tall, broad-shouldered profile or a wide-waisted, spheroid shape, as if James had plucked a disk from a Gottlieb painting and blown it full of air—a moon come to earth.

The place of greatest articulation, the lip of the vessel, is handled with ever increasing sensitivity. In *Big Apple #5* (cat. 21) the even roll of the lip differs little from that of a thrown piece. Other works from this period, however, exhibit the modulations of the opening, gentle dips and rises, for example, that

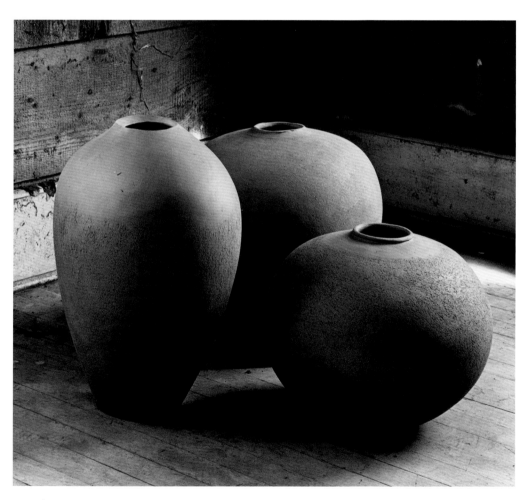

Three pots, 1978. Photo by Mary Randlett

became a hallmark of James's vessels (pp. 46, 48). No glaze or surface decoration, except traces left by fire and smoke, diverts from these subtleties. James would say this is due to his lack of technical expertise. His clear interest, however, is in the clay as earth, not as surface for something else, and in the exploration of volume, particularly the sense that interior air pressure is stretching the skin of the pot.

Ceramics in the Pacific Northwest (1979) by La Mar Harrington illustrates James's *Warrior Head* of 1974. Although Harrington mentions James's "fifty-pound, monumental, coil-built pots fired with primitive techniques," none are reproduced.[12] James's major vessels were just being made as the book was on press. "How could I have omitted his pots?" Harrington said recently, and was relieved to recall an error of timing rather than of taste. She calls his forms "absolutely unique" and, interestingly, places them in the modernist tradition, citing a Bauhaus-like simplicity. James's recent statement that he "had a philosophy that embellishment is unnecessary" concurs in that sense. Otherwise he thinks of his vessels as combining American Indian and Japanese influences.

No one was doing work quite like James's. Robert Sperry, the head of the ceramics department at the University of Washington, had worked at the Archie Bray Foundation in the 1950s with Peter Voulkos and Rudy Autio, as had the McKinnells. He made large glazed pots that shared James's interest in the classical vessel format, but by the 1980s was concentrating on stark, gestural, black-and-white-glazed tiles and platters. His use of the wheel and

emphasis on surface design rather than volume easily differentiate his work from James's. Sperry's colleagues Howard Kottler and Patti Warashina were among the leaders of the West Coast avant-garde. Their bright, low-fire glazes and intellectualized subject matter fell at the opposite end of the aesthetic spectrum from James's work. East Coast potter Toshiko Takaezu shared James's interest in sphere-like shapes, but she always threw her vessels and was unparalleled in her subtle use of glazes. Other potters who worked in a primitivist vein, handbuilding and wood-firing their unglazed pieces, did not attain the elegance, subtlety, and scale of James's best work.

As James continued to build vessels in the early 1980s, his modulation of form became subtler and the asymmetry of his handbuilt pots more conspicuous. The pieces are not just stretched but breathe. Barbara James says that *Grand Kiva* (1980, p. 49) is "alive." James remarks that the piece "makes me weep," and he is not alone. *Quail* (1981, p. 53), named as usual by Barbara, exhibits an understated asymmetry and bird-like softness that evokes the title. A vessel from around 1982 (pp. 54–55) of breathtakingly extreme width leads James to recall the Anasazi pieces he saw in the Southwest: "They seem to stretch to infinity before they come back."

After 1985 James ceased making vessels but continued to work in clay. He created sculptures in which the influences of Moore and Brancusi are apparent, but the influences of geology and biology are as great. These ceramic sculptures from the 1980s, and the bronzes later cast from them, depict two parts merging or splitting. The vessels, in

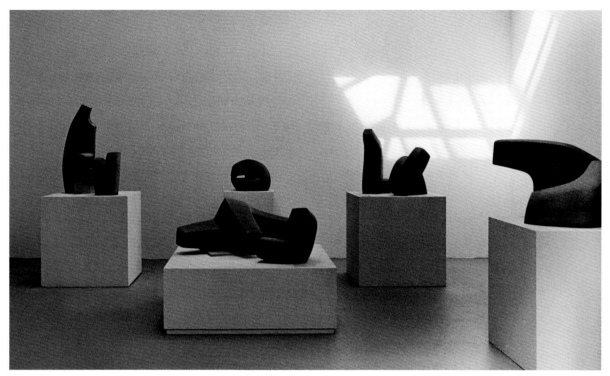

Aerobic Figures at Traver/Sutton Gallery, Seattle, 1988. Cat. 52 is in the rear center.
PHOTO BY MARY RANDLETT

contrast, are self-contained, singular, and large for pots, while the sculptures are generally small in scale even when monumental in feel. In *Ancient Mounds* (1986, p. 57) the halves are nestled together, part mother and child, part fissioning cell. *Seed* (p. 62), a 1991 bronze cast from an earlier clay sculpture, suggests a similar cellular division, although James believes the parts are "definitely coming together, not separating." In *Continental Shift II* (1988, p. 61) the break of one into two is complete, and the reference—plate tectonics—is geologic rather than microscopic. These sculptures testify to James's continuing interest in the philosophic issue of unity versus opposition, and in the Vedantic view that all is one. Even though the sculptures are bifurcated, the parts are not battling each other; they are segments of a whole—merging, cleaving, or mutually supporting.

James created other series of sculpture in the late 1980s. His "hole-y rock period" (p. 63) was inspired by stones picked up on Washington's Rialto Beach as well as the continuing influence of Moore.[13] The Aerobic Figures Series of 1988 resulted from James's attention to baseball players in action and, perhaps, the work of sculptor Joel Shapiro, which was exhibited at Seattle Art Museum in 1986. A series of monumental oval forms were his final works in clay. James's aging back and hands and never-ending technical problems conspired to end his career as a sculptor except for recent bronze castings of older works.

The oval sculptures (pp. 21, 64–67) are large,

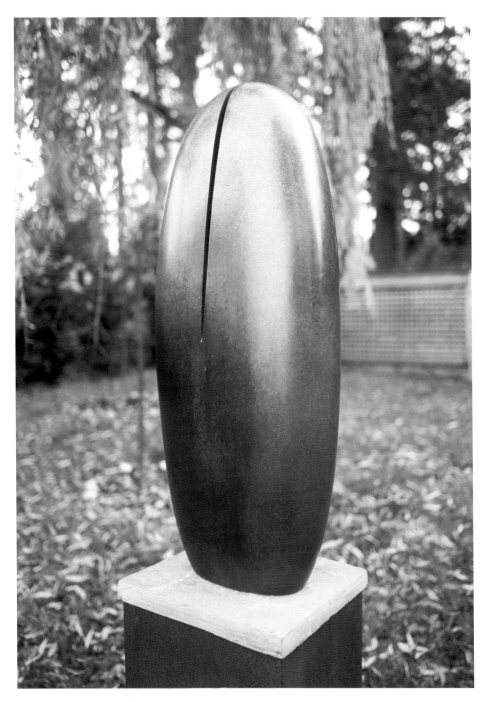

Frost Wedge, 2001 (cat. 59) PHOTO BY TOM KELLY

singular, symmetrical objects similar to the vessels but without the opening that turns a sculpture into a pot, or the tension that accompanies implied swelling. The ovals may be scored or split like the bifurcated sculptures, but with less sense of division and less interruption of the contour. James says they are "self-contained" and "quiet, like an egg." Titles such as *Eclipse* and *Klee Moon* reinforce celestial analogies and the mystical tone that often touches James's work. These pieces bring together the beaches where James collects stones and Japanese Zen gardens, where boulders replace plants. When James's eggs are placed in gardens, as they often are, they stand on plinths of his design and become the still foci of changing landscapes.

James thought he had conquered the technical problems of ceramics when he made the ovals, and he waited to fire them en masse before exhibiting them at the Gordon Woodside/John Braseth Gallery in Seattle:

> I was just very happy building things out of clay. It was the perfect medium for me and I was good at it. But firing and glazing I just could not master, ever. My last show in Seattle was in 1991. I had really thought I'd licked it. I got a clay body that was really functioning well. So I built all these large sculptures, and I was so sure that everything was going all right that I spent the whole year building these things and just letting them sit, which is a good idea, then started to fire them and busted every one of them, blew the bottoms out of them. So I learned how to patch. I got out of jail when I quit ceramics.

Painting en Plein Air

Artist Paul Havas, who moved to La Conner in 1970, thinks of Clayton James as a painter, not a sculptor. When the two met shortly after Havas arrived, James was grumbling about the problems of casting concrete and Havas was in turmoil about subject matter in his painting—abstraction or realism, cityscapes or landscapes, farmland or wilderness? "I thought the Skagit Valley would solve all my aesthetic problems," Havas says. James understood these problems and had decided that his own best paintings were those made en plein air as a student in Provincetown. One evening in the mid-1970s, as the two were sitting on the Jameses' deck drinking Clayton's homemade wine, they decided to paint in nature together on weekends. Sunday painters. "It was daring then. You were considered naïve and retro," Havas says about their well-seasoned subject matter.

In the 1980s James and Havas took one or two extended annual trips in Washington or Oregon, exploring hidden coulees, camping by streams, foraging for food, and painting side by side. Unlike western Washington, there was abundant sunshine in the east, space-defining shadows, and fabulous rock formations. Havas notes that James was more drawn to the rocks than he was and tended toward simpler compositions: "He's an observer of relationships in nature." These interests are consistent with the focus and classicism of his sculpture, which in turn was fed on these trips. When James and Havas drove back, the dashboard of the car was covered with seed pods and chunks of basalt, a "mantelpiece of stuff" for inspiration.

In the 1990s James and Havas explored the

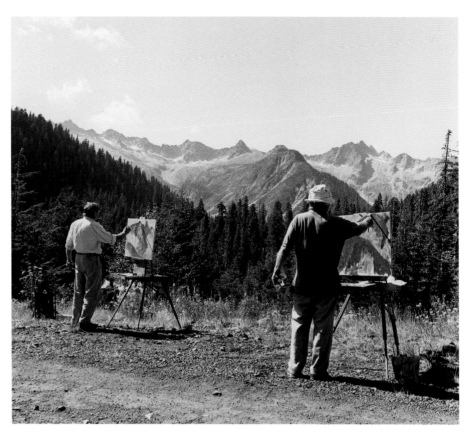

Paul Havas (left) and Clayton James painting in the Mount Baker National Forest, 1995.
PHOTO BY MARY RANDLETT

Washington coast and Baker Lake areas. Gradually James began to paint the sky, an indication, perhaps, that he had truly abandoned the world of solid sculpture. These sometimes Turneresque paintings take full advantage of what Havas calls Clayton's "great tonal sense." Although James still complains about the weather of the Northwest, he's finally let the moisture seep into his work. The Skagit Valley is most present in works like *Hanging Sky* (pp. 34–35) in which broad, flat land mirrors the immense cloud-laden heavens. Light emerges from behind the hills. *Yellow Night* (1961, p. 30), James's early mystical abstraction, has been subsumed by the environment outside his door.

When James turned from wood to ceramics, he was amazed at the speed and freedom he gained. A few days of building and his sculpture was done. He could easily fix mistakes during construction, and there was no tedious sanding. But the ceramic pieces busted either during firing or after, when toppled by a cat, kicked by a foot, or cracked by a freeze. Bronze is permanent but laborious. The wax used as a base for the casting is unpleasant, the grinding is monotonous and wearing, and the patinas frustrating to perfect. Painting is the most immediate process and the fastest. James does not complain about this medium; he has recovered the joy he found in handbuilding clay.

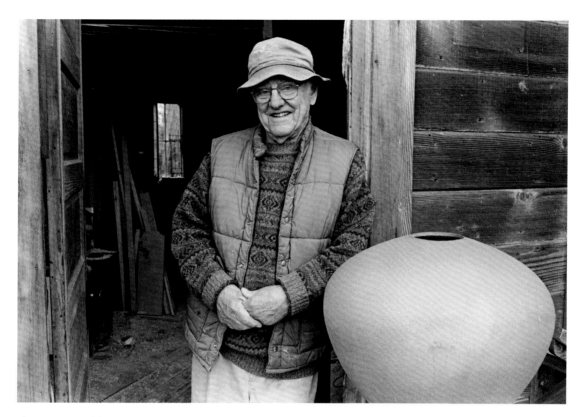

Clayton James with one of his handbuilt pots, 2001. PHOTO BY EDUARDO CALDERÓN

The organic garden beside the Jameses' house has been cultivated for fifty years. The house itself, slightly enlarged since they moved there, is otherwise unchanged. Crossing the road and entering his studio, Clayton, at eighty-three years of age, passes some of his sculptures, lichen-covered and cracked. His kiln is still in the yard. So is a new bronze oval whose patina he scrutinizes. Stacked inside are paintings that couldn't be finished outdoors, waiting for completion.

I try to finish them in the field, but you poop out. It's very strenuous. After two hours you've had it, so you say, well I'll just take it home and finish it. Then I begin to wonder, why do I care? Why do I want to finish them? Then I get into the business of communication. What am I doing it for? Just to please myself, my own little ego? If you can make the painting work, it's much better.

When James is done trying to make the painting work, he returns to his house. *Grand Kiva* sits in a corner, quietly breathing.

Notes

1. Graves was not granted conscientious objector status, supposedly because of errors in his filing. He was eventually considered unsuitable for the army and given an honorable discharge, which he refused. For this and other information about Morris Graves, see Ray Kass, *Morris Graves: Vision of the Inner Eye* (Washington, D.C.: The Phillips Collection, 1983).

2. All quotations are from conversations with the author in 2001 and 2002 unless otherwise stated.

3. Adrian Wilson, *Two Against the Tide: A Conscientious Objector in World War II, Selected Letters 1941–1948* (Austin, Tex.: W. Thomas Taylor, 1990), pp. 88, 95.

4. E-mail from Barbara James to author, December 6, 2001.

5. Sheila Farr, "The House That Morris Graves Built," *Seattle Times*, December 9, 2001.

6. Wilson, *Two Against the Tide*, pp. 165–66.

7. "The Japanese-American sculptor and furniture designer George Nakashima and his wife Marian stayed with Graves's mother before they were to be removed to a detention center for the duration of the war, and were there when Graves arrived to turn himself in to the military police. . . . Upon his arrival at the Fort Lewis stockade, Graves was interrogated about his possible collusion with the Japanese. . . . and the Nakashimas were subjected to an investigation." Kass, *Morris Graves: Vision of the Inner Eye*, p. 35.

8. Quoted in *woodmagazine.com/hallfame/nakashima.html*.

9. "The Mystic Painters of the Northwest," *Life* (September 1953).

10. See Kass, *Morris Graves: Vision of the Inner Eye*, pp. 59–60, for a full description of "an authentic piece of conceptual theater"; Deloris Tarzan Ament, "Morris Graves: Northwest Gothic," in *Iridescent Light: The Emergence of Northwest Art* (Seattle: University of Washington Press, 2002), pp. 126–27.

11. Tom Robbins, *Skagit Valley Artists* (Seattle: Seattle Art Museum, 1974), p. 7.

12. La Mar Harrington, *Ceramics in the Pacific Northwest* (Seattle: University of Washington Press, 1979), p. 121.

13. This work by James in turn inspired the sculptor Jeff Day, a good friend who often creates the patinas on James's bronzes.

Plates

Untitled (Island Landscape), 1956 (cat. 2)

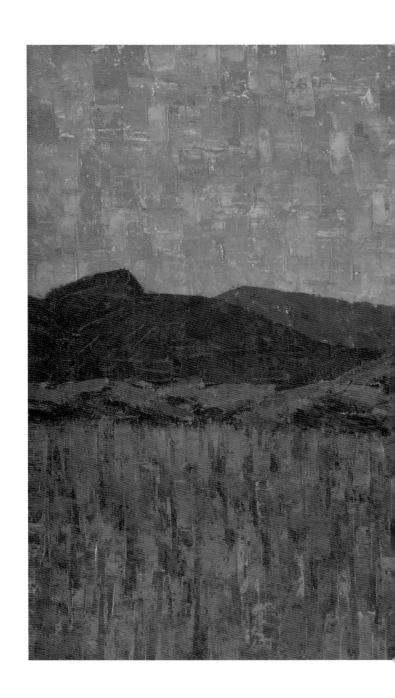

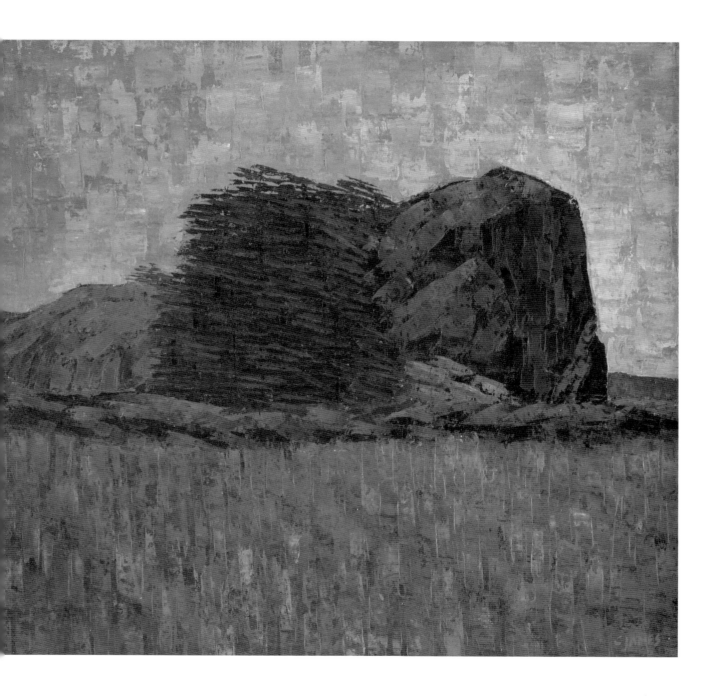

Yellow Night, 1961 (cat. 5)

Beached Moon, 1960s (cat. 6)

Glacial Haystacks, Waterville Plateau, 1997 (cat. 9)

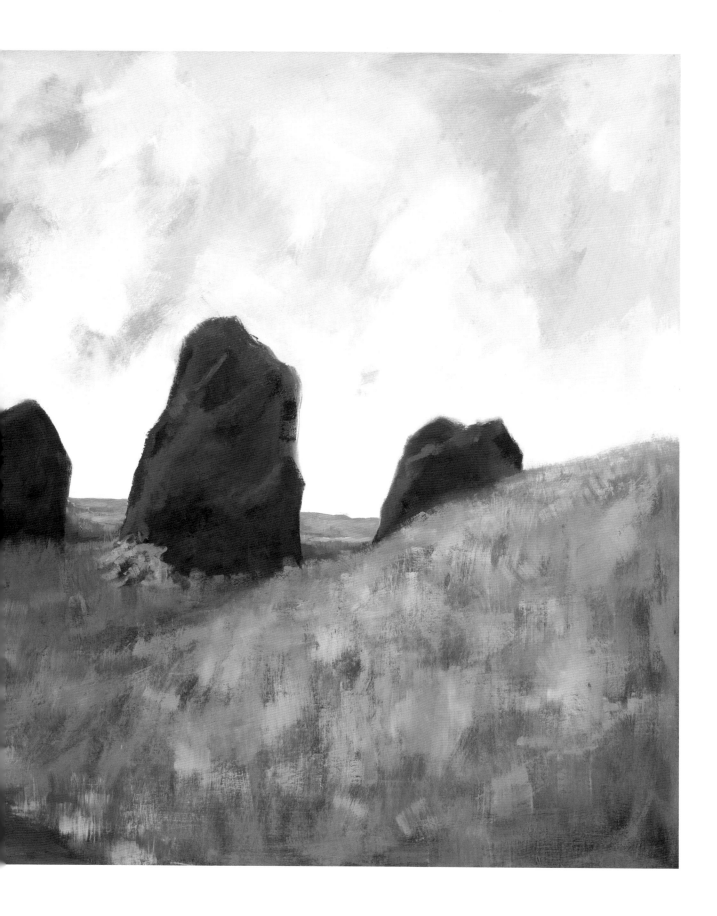

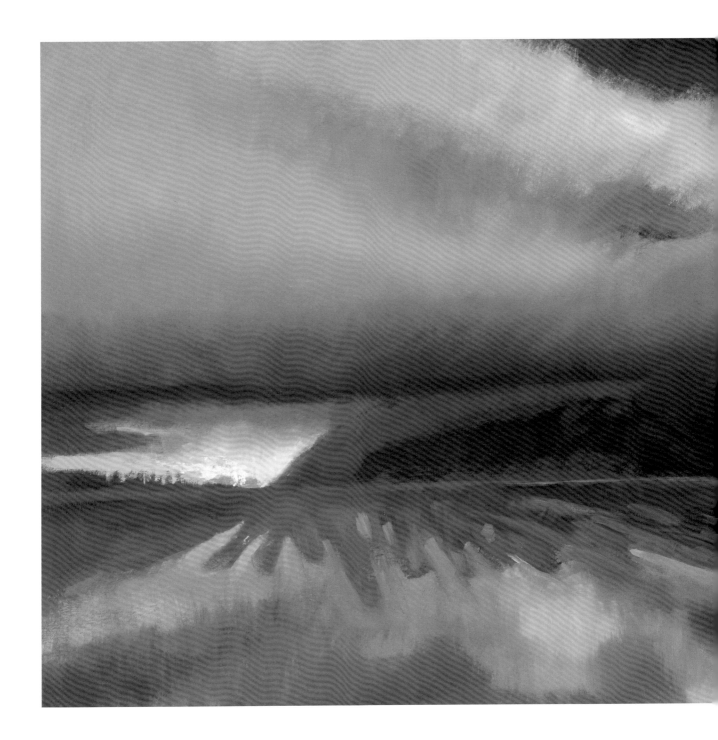

Hanging Sky, 1999 (cat. 10)

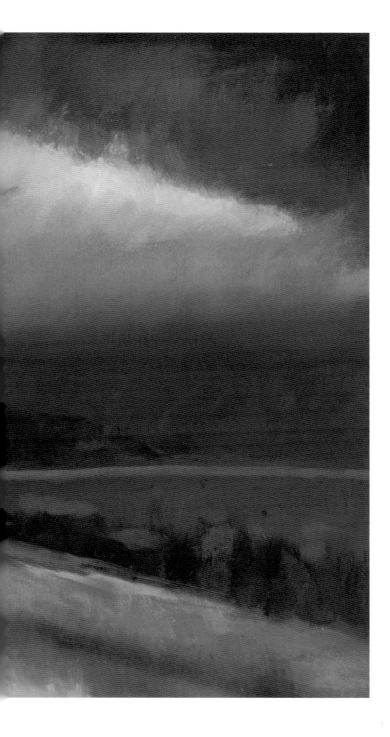

War Helmets, 1975 (cats. 17–18) *Ode to de Chirico's "Nostalgia of the Infinite,"* 1975 (cat. 19)

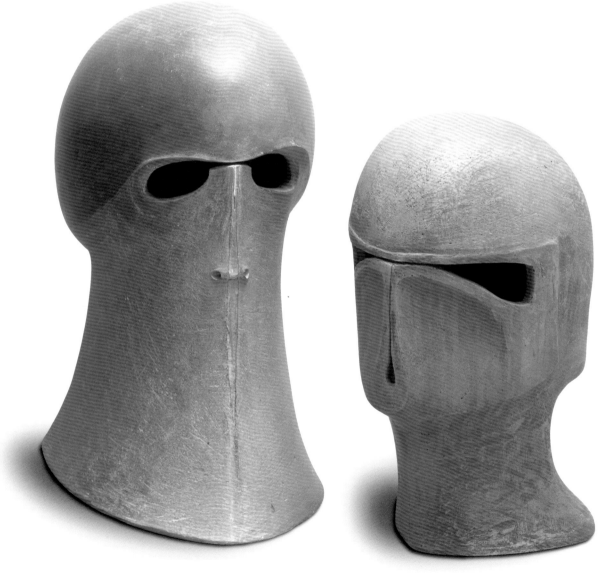

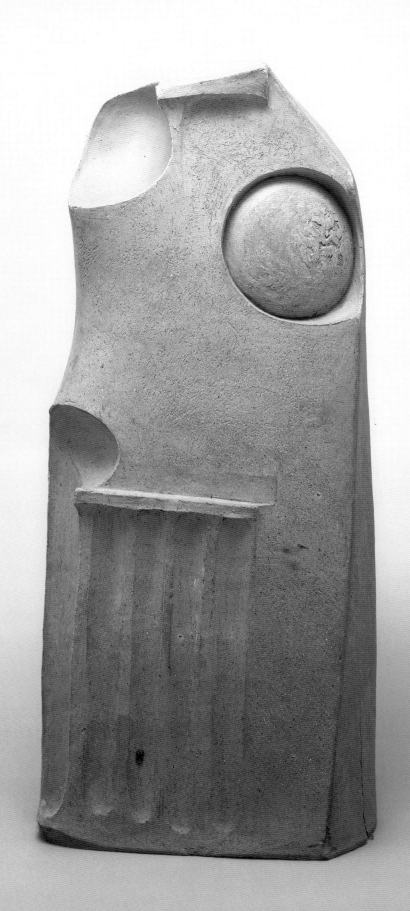

Pomegranate, 1978 (cat. 22) *Thistle Top,* ca. 1978 (cat. 23)

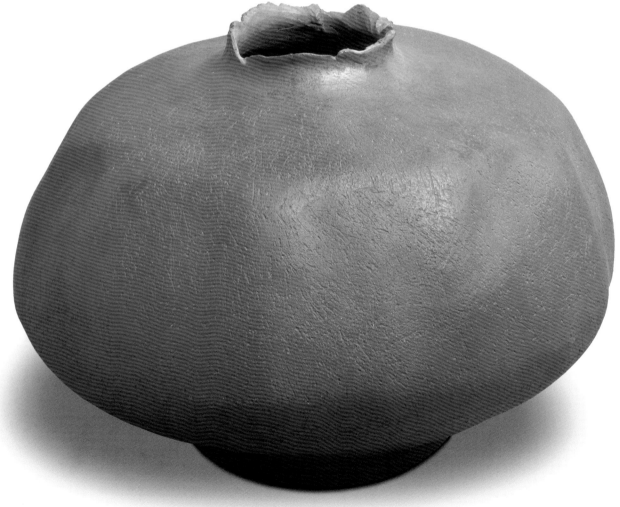

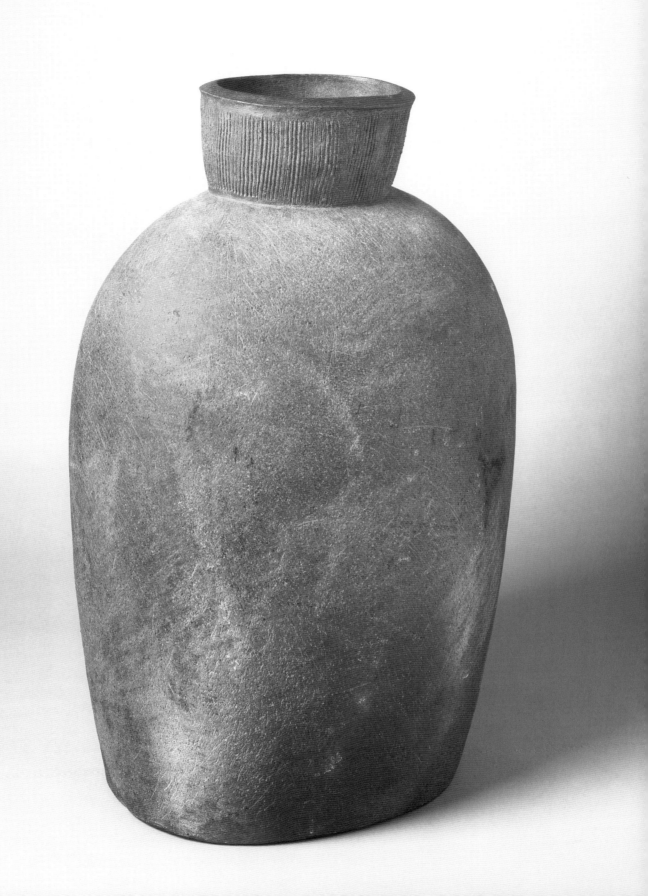

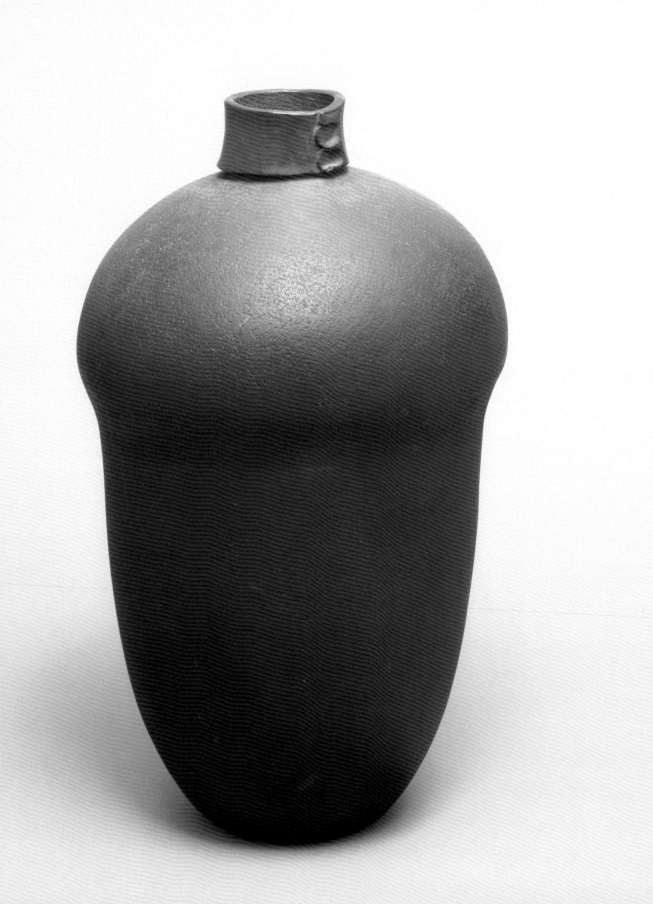

Smoky Urn, 1979 (cat. 24) *Sung Jar,* 1979 (cat. 25)

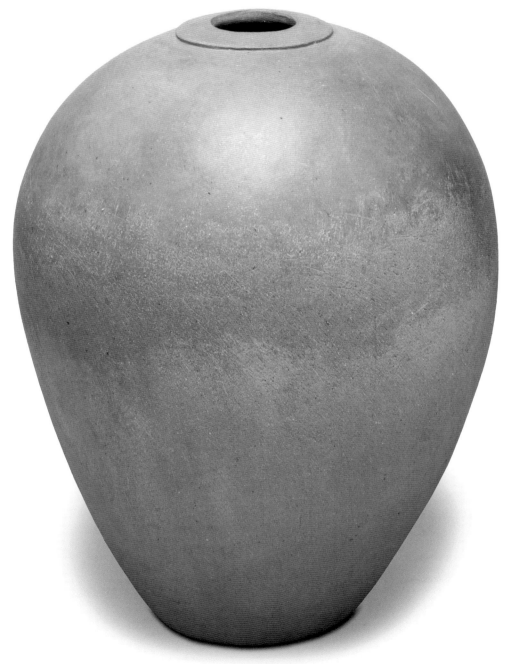

Untitled (T-shape), ca. 1980 (cat. 26) *Crossed Torso*, ca. 1980 (cat. 27)

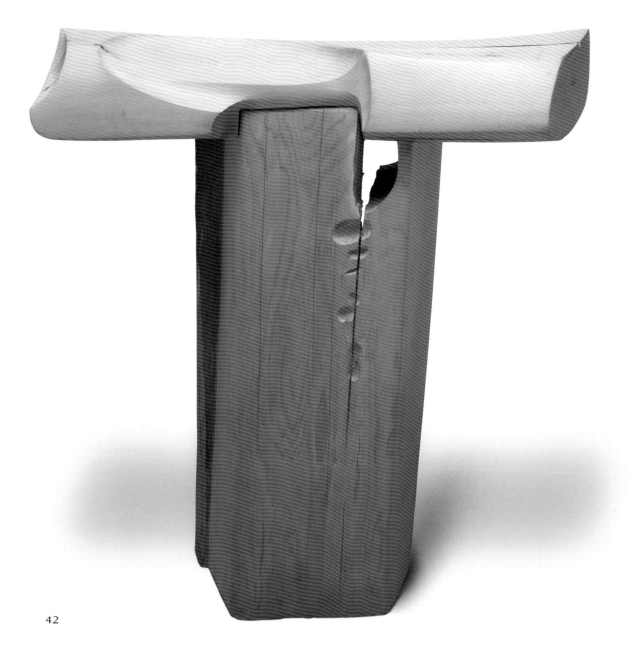

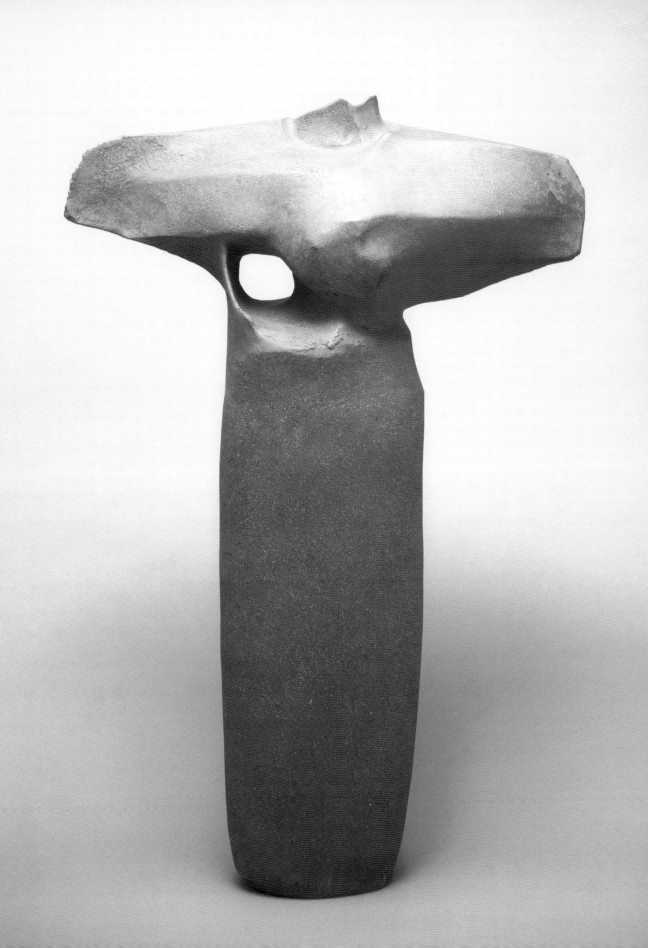

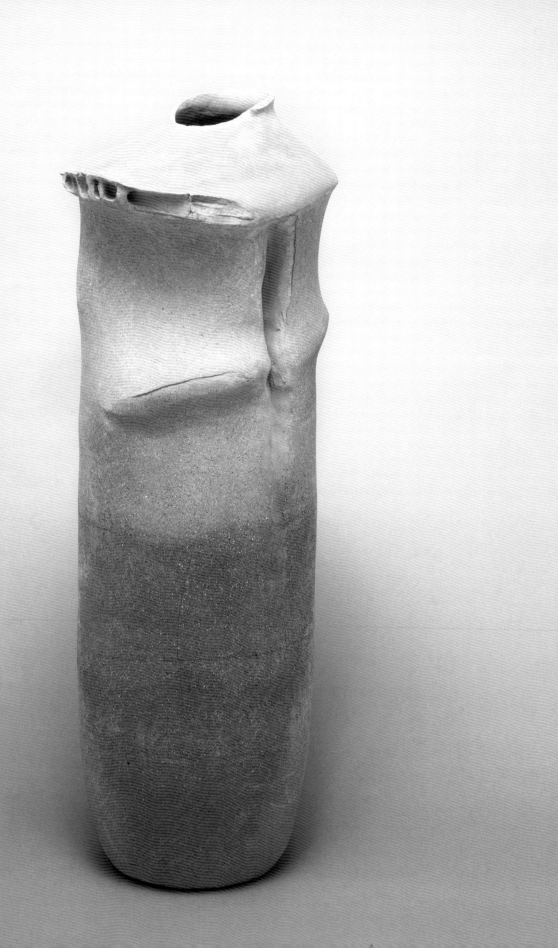

Untitled (Geological Pot), ca. 1980 (cat. 28) *Black Rock,* ca. 1980 (cat. 29)

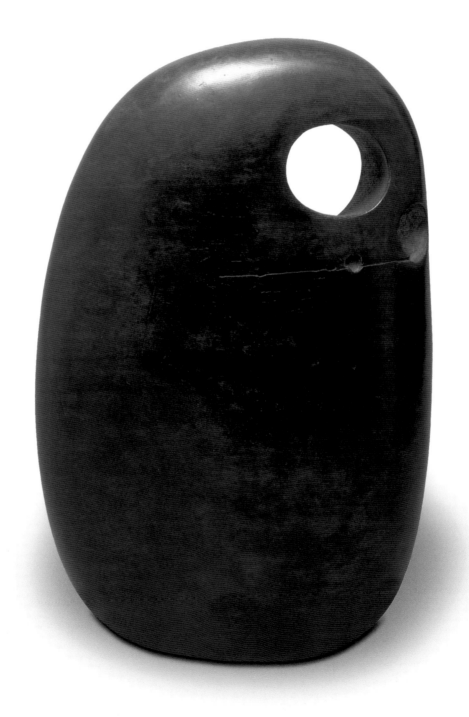

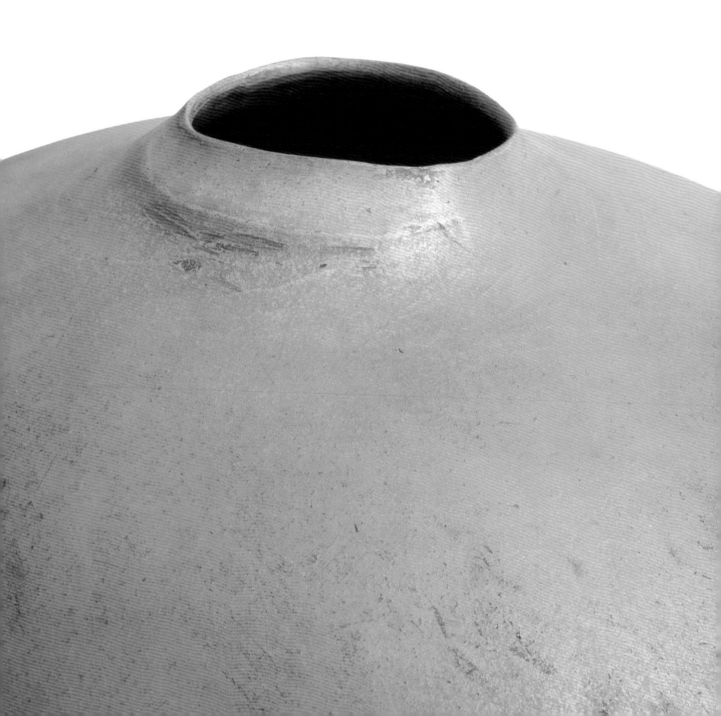

Pumpkin Pot (detail)

Pumpkin Pot, 1980 (cat. 32)

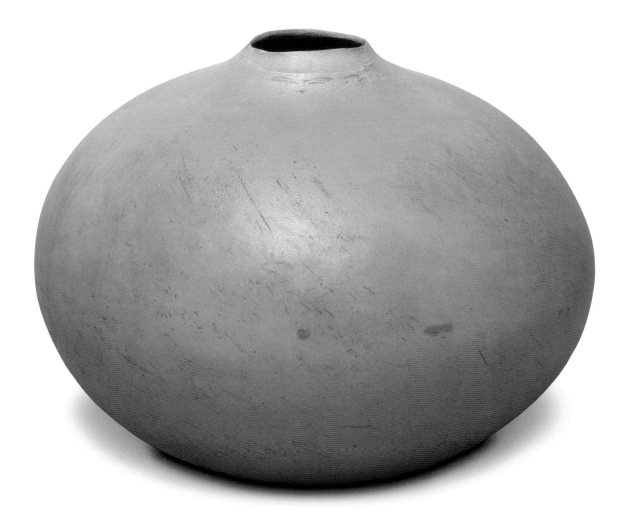

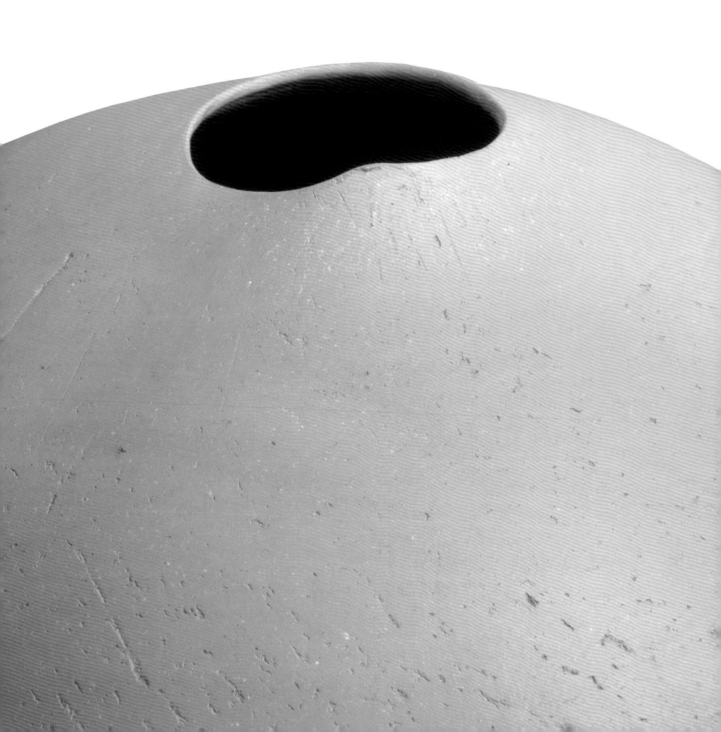

Grand Kiva (detail)

Grand Kiva, 1980 (cat. 33)

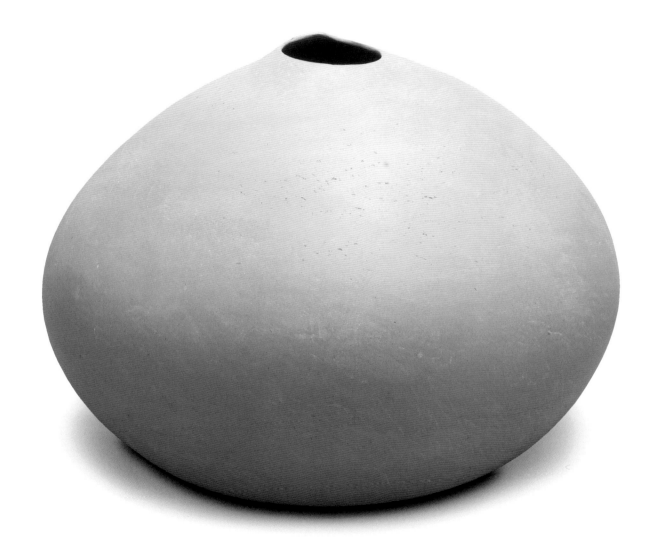

Untitled (Smoked Pot), 1980 (cat. 34)

Anasazi Series: Winter Melon, 1981 (cat. 35)

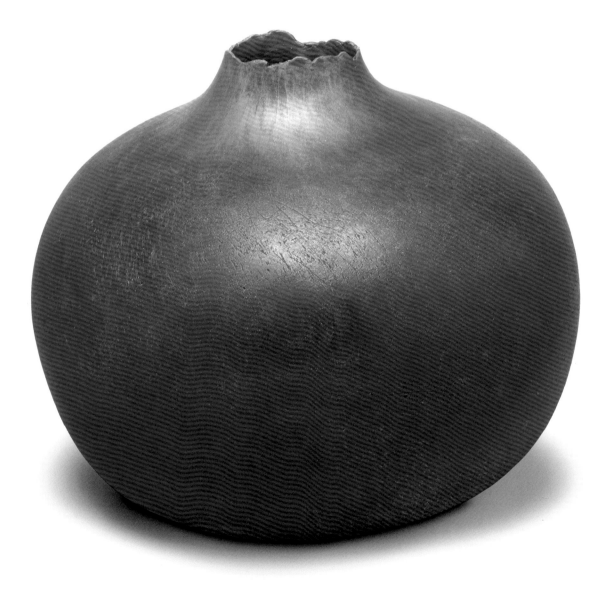

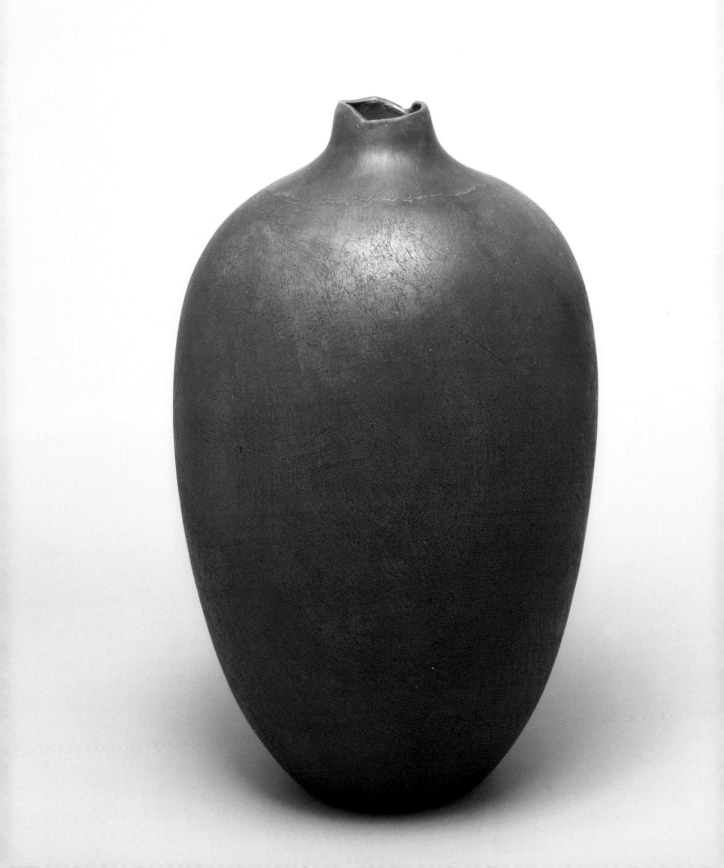

Untitled (Spheroid Pot), 1981　(cat. 36)

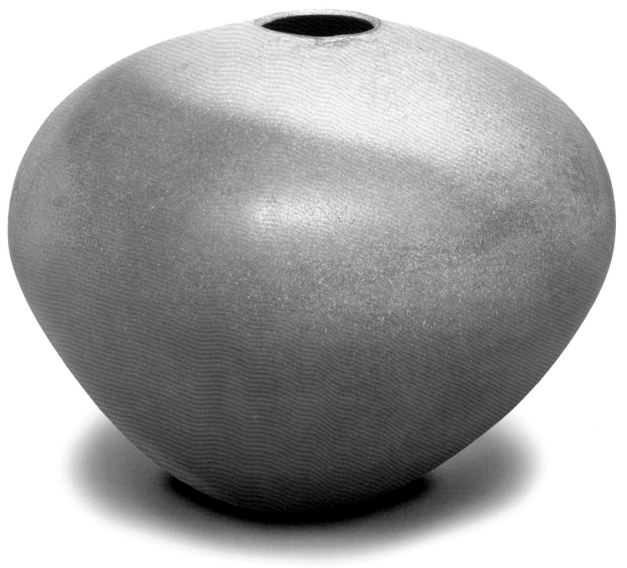

Quail, 1981 (cat. 37)

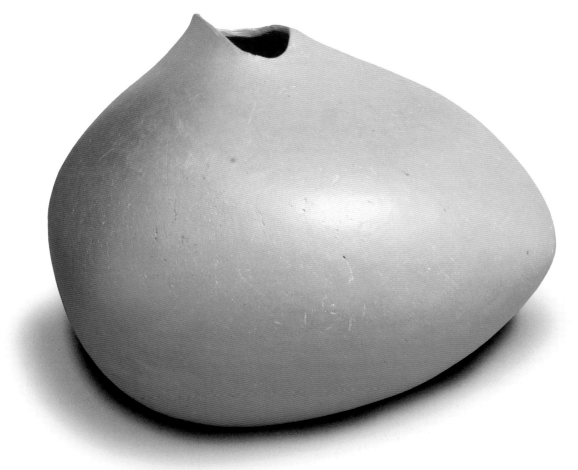

Untitled (Spheroid Pot), ca. 1982 (cat. 39)

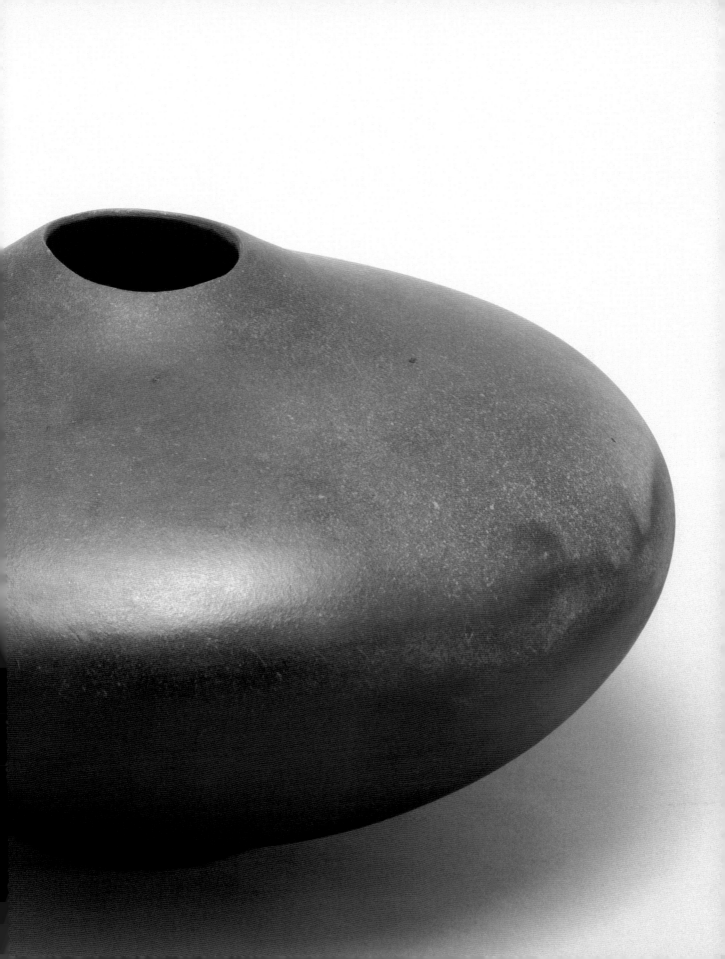

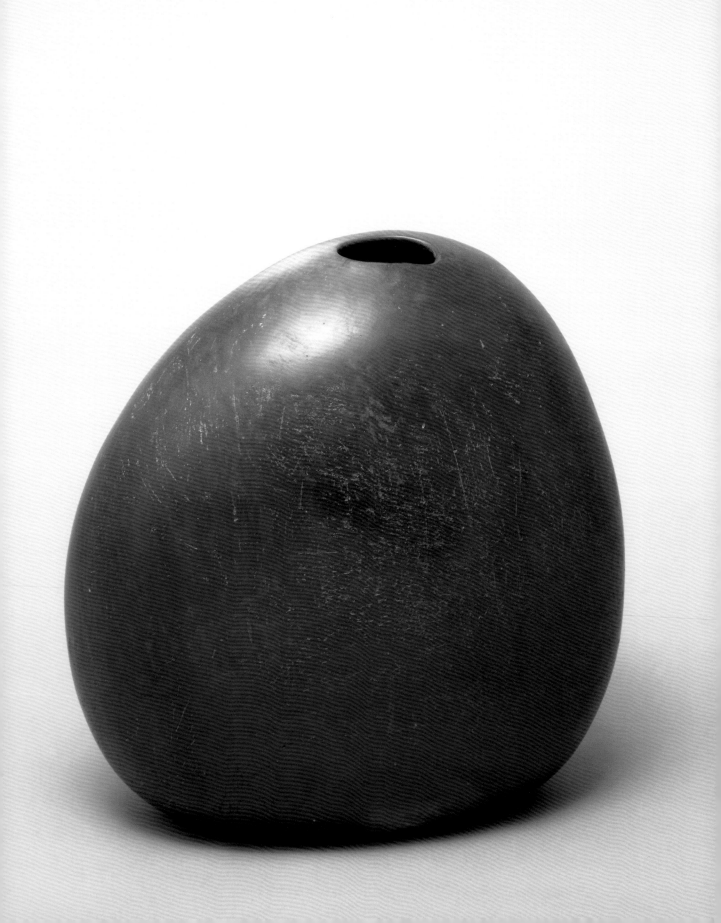

Dark Drupe, 1983　(cat. 41)　　　　　　　　　　　　　*Ancient Mounds,* 1986　(cat. 45)

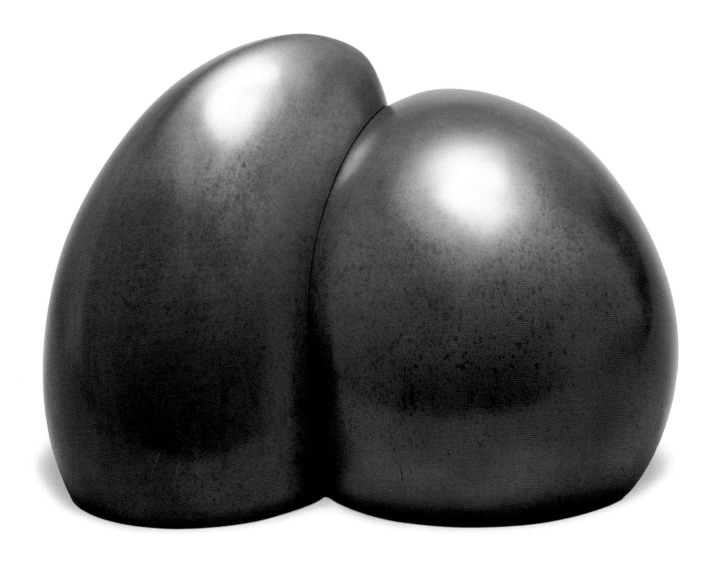

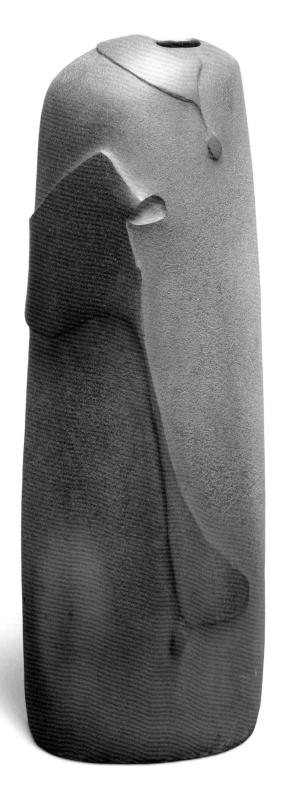

Untitled (Tall Slender Pot), 1985 (cat. 42)

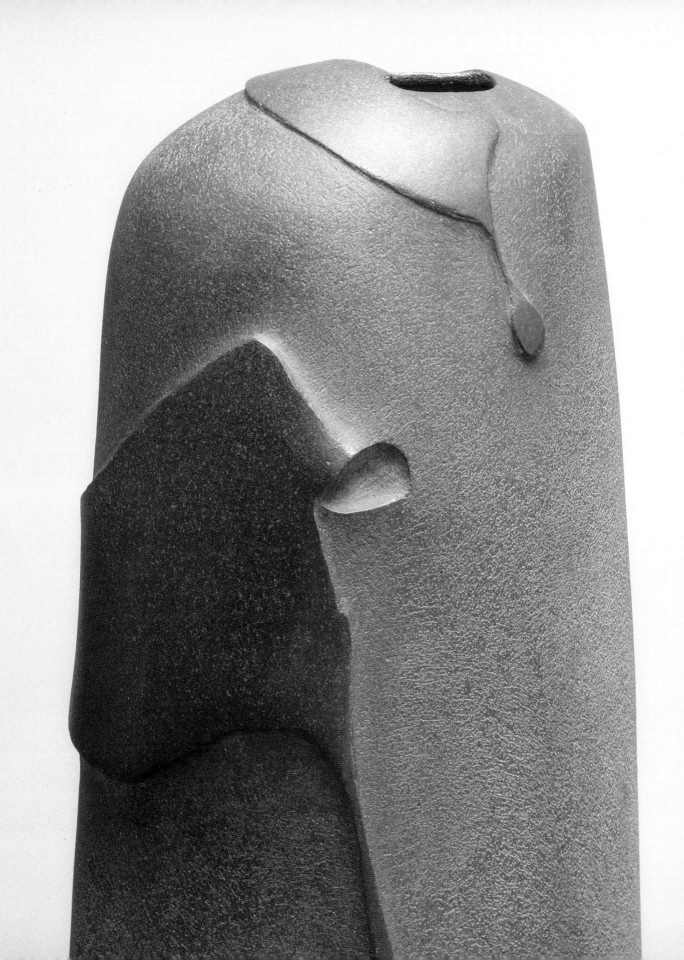

Off Shore Island, 1988 (cat. 47)

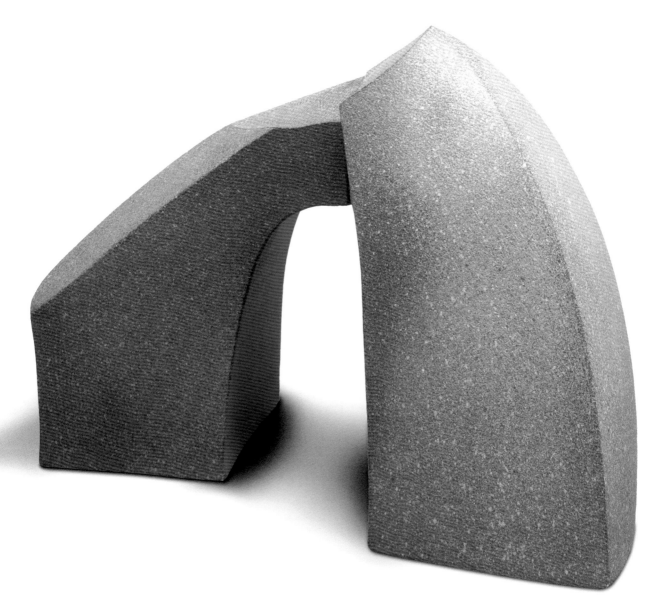

Continental Shift II, 1988 (cat. 53)

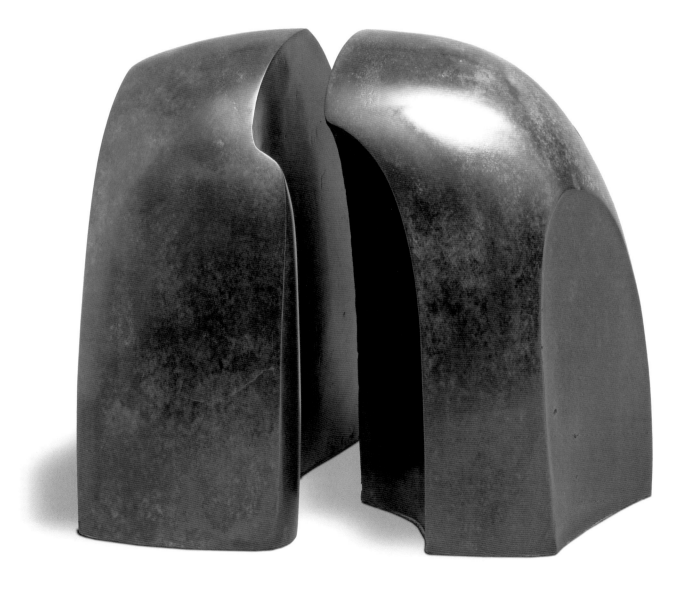

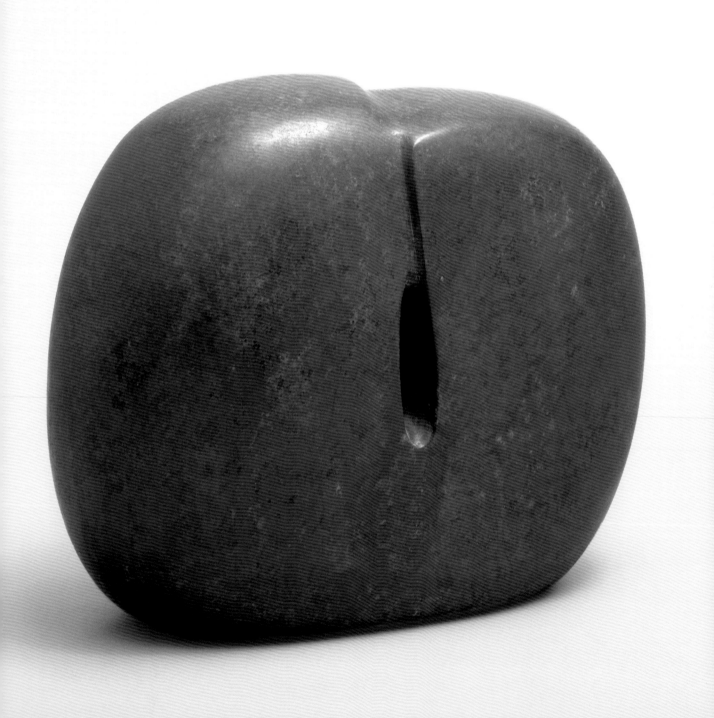

Seed, 1991 (cat. 56) *Untitled (Cyclops)*, 1988 (cat. 46)

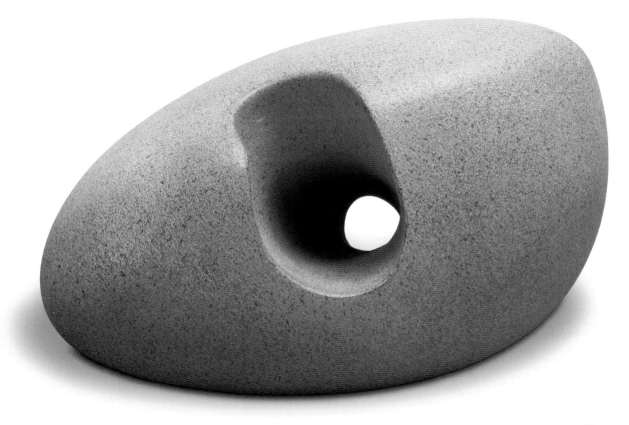

Klee Moon, 1988 (cat. 50) *Nutcracker,* ca. 1990 (cat. 55)

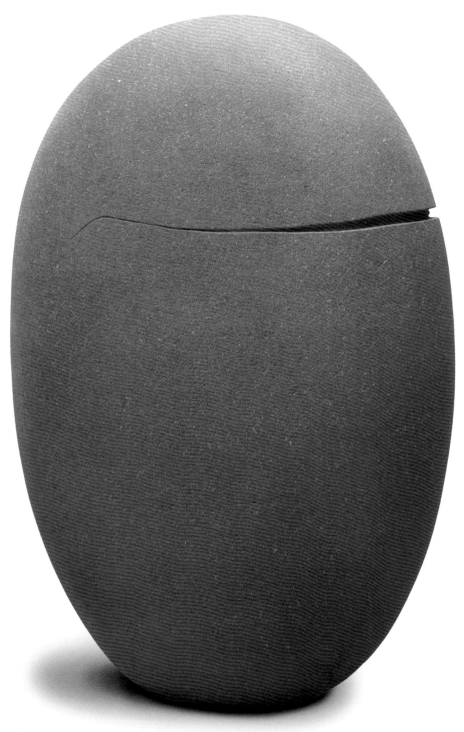

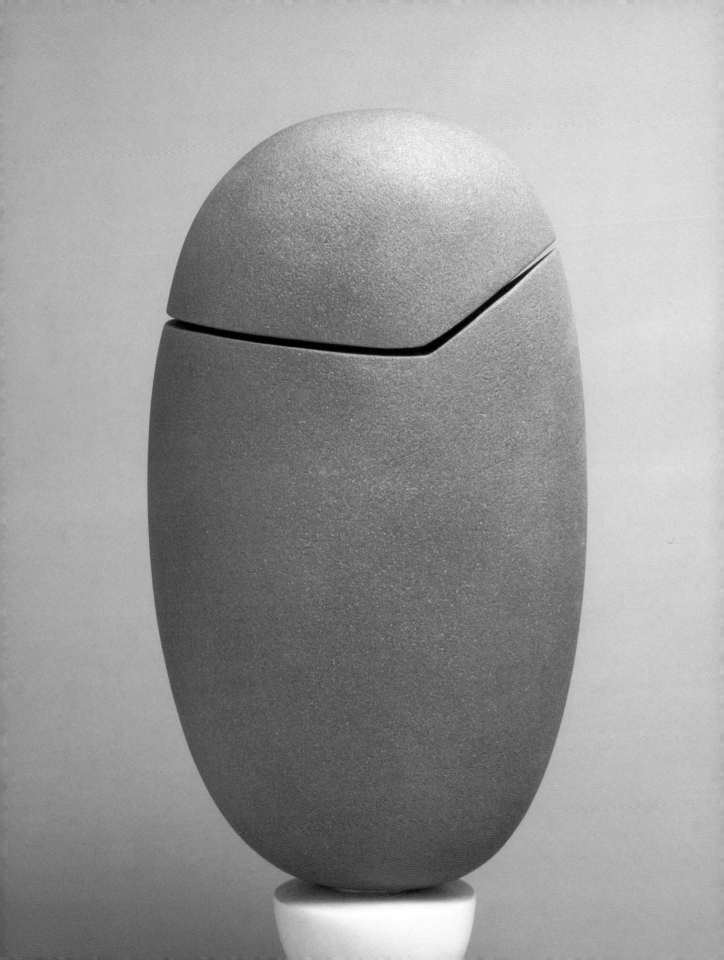

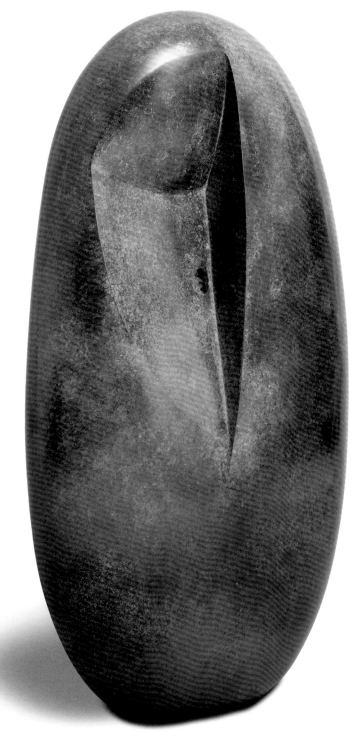

Oval Series with Cleft, 2001 (cat. 58)

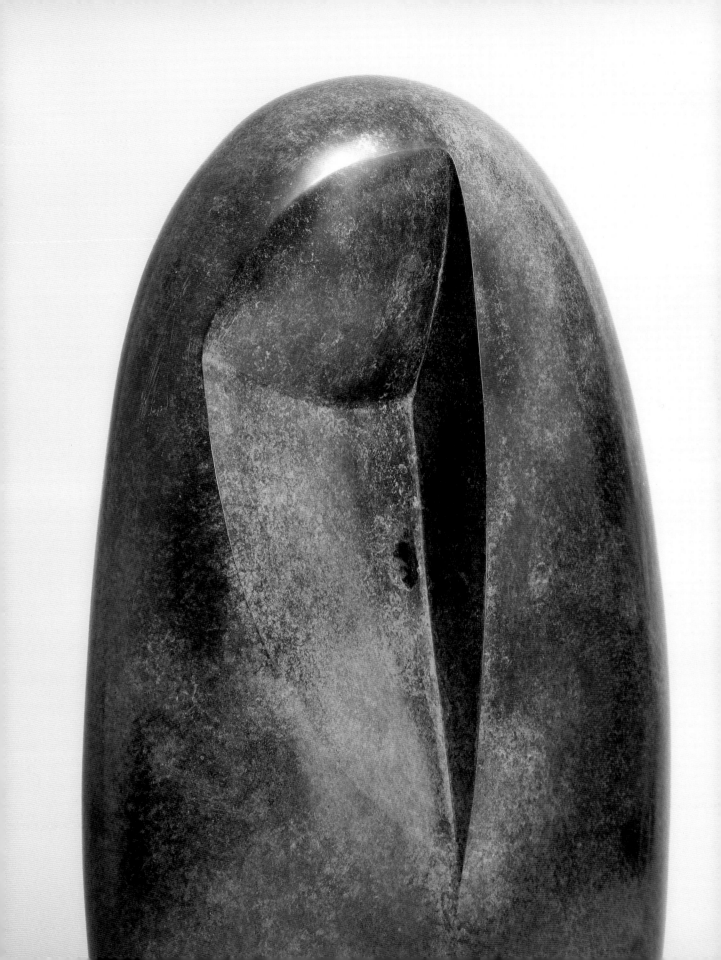

Catalog of the Exhibition

Dimensions are in inches; height precedes width precedes depth. Photography by Eduardo Calderón except as noted.

Paintings

1. *Silvana,* ca. 1956
 Oil on canvas
 14 × 32
 Collection of Hans and Elaine Jorgensen and Gale De Marsh

2. *Untitled (Island Landscape),* 1956 (p. 28–29)
 Oil on linen on Masonite
 24¼ × 43½
 Museum of Northwest Art, La Conner, Washington, gift of Jan Budden and Kitty Ford

3. *October,* 1960
 Acrylic on board
 40⅝ × 65½
 Courtesy of the artist

4. *Eclipse,* 1960
 Acrylic on canvas
 40 × 65
 Collection of Thomas S. Bayley

5. *Yellow Night,* 1961 (p. 30)
 Acrylic on canvas
 38¼ × 67⅜
 Museum of Northwest Art, La Conner, Washington, gift of Phyllis D. and Robert Massar
 Photo by Tom Kelly

6. *Beached Moon,* 1960s (p. 31)
 Oil on canvas
 30 × 60
 Collection of Caroline Locher
 Photo by Paul Foster

7. *Moses Coulee,* 1980
 Oil on wood
 15 × 17
 Collection of Paul and Margaret Havas

8. *Sisters from Route 9, Acme,* 1986
 Oil on wood
 22½ × 58¾
 Courtesy of the artist

9. *Glacial Haystacks, Waterville Plateau,* 1997 (pp. 32–33)
 Oil on canvas on board
 36 × 45¼
 Courtesy of the artist

10. *Hanging Sky,* 1999 (pp. 34–35)
 Oil on wood
 30 × 50
 Collection of Nancy Keith

11. *Winter Sky,* 1999
Oil on wood
27 × 33
Collection of David and
Cathy Hall

12. *Near Conway,* 2000
Oil on wood
30 × 54
Collection of People's Bank,
Bellingham, Washington

Sculpture

13–15. *Three Mini Root Sculptures,*
1972
Carved driftwood
9½ h, 13 h, 9¾ h
Collection of Anne Gould
Hauberg

16–18. *War Helmets,* 1975 (p. 36)
Clay
19½ h, 19½ h, 15¾ h
Courtesy of the artist

19. *Ode to de Chirico's "Nostalgia of
the Infinite,"* 1975 (p. 37)
Clay
33½ × 15 × 8
Collection of Barbara and
Clayton James

20. *Stone Pot,* 1975
Clay
24 × 16 × 14
Collection of Hans and
Elaine Jorgensen

21. *Big Apple #5,* 1978
Clay
17 × 18 × 18
Collection of Hans and
Elaine Jorgensen

22. *Pomegranate,* 1978 (p. 38)
Clay
12½ × 18 × 18
Collection of Hans and
Elaine Jorgensen

23. *Thistle Top,* ca. 1978 (p. 39)
Clay
28 × 18 × 14
Collection of Caroline Locher
Photo by Paul Foster

24. *Smoky Urn,* 1979 (p. 40)
Clay
26½ × 16 × 16
Whatcom Museum of History
and Art, Bellingham, Wash-
ington, gift of Barbara and
Clayton James in memory
of Jean Wilson Wagner

25. *Sung Jar,* 1979 (p. 41)
Clay
24 × 19¾ × 19¾
Whatcom Museum of History
and Art, Bellingham, Washing-
ton, gift of Wilbur and Dinah
Kukes

26. *Untitled (T-shape),* ca. 1980
(p. 42)
Wood
23¼ × 23¾ × 9½
Courtesy of the artist

27. *Crossed Torso,* ca. 1980 (p. 43)
Clay
40¼ × 28½ × 9¼
Collection of Barbara and
Clayton James

28. *Untitled (Geological Pot),* ca. 1980
(p. 44)
Clay
32 × 12½ × 11¼
Collection of Barbara and
Clayton James

29. *Black Rock,* ca. 1980 (p. 45)
Raku-fired clay
22½ × 14 × 7¼
Collection of Stoel Rives LLP,
Seattle

30. *Untitled (High-Shouldered Pot),*
1980
Clay, granite base
21 × 21 × 21 without base
Collection of Douglas and
Patricia Ikegami

31. *Untitled (Tall Orange Pot),* 1980
Clay
26½ × 14 × 14
Collection of Brent Goeres

32. *Pumpkin Pot,* 1980 (pp. 46, 47)
Clay
15 × 20¾ × 20¾
Collection of Leslie Strong

33. *Grand Kiva*, 1980 (pp. 48, 49, cover)
Clay
14 × 20 × 20
Collection of Barbara and Clayton James

34. *Untitled (Smoked Pot)*, 1980 (p. 50)
Clay
20 × 22 × 22
Collection of Marcella Benditt

35. *Anasazi Series: Winter Melon*, 1981 (p. 51)
Clay
23¾ × 12½ × 12½
Collection of Caryl Roman

36. *Untitled (Spheroid Pot)*, 1981 (p. 52)
Clay
15¼ × 21¼ × 22
Collection of John Voorhees and Michael Cunningham

37. *Quail*, 1981 (p. 53)
Clay
9 × 13 × 10½
Collection of Hans and Elaine Jorgensen

38. *Untitled (Spheroid Pot)*, 1981
Clay
14½ × 23 × 23
Collection of Paddy McNeely

39. *Untitled (Spheroid Pot)*, ca. 1982 (pp. 54–55)
Clay
12 × 23 × 23
Collection of Theresa Doherty and Joseph Peterson

40. *Untitled (Spheroid Pot)*, ca. 1982
Clay
11 × 16 × 16
Collection of Jesse Hiraoka and Louise Kikuchi

41. *Dark Drupe*, 1983 (p. 56)
Raku-fired clay
18 × 18 × 12¾
Collection of Barbara and Clayton James

42. *Untitled (Tall Slender Pot)*, 1985 (pp. 58, 59)
Clay
34¼ × 13½ × 10
Collection of Becky and Jack Benaroya

43. *Untitled (Tall Slender Pot)*, 1985
Clay
Approx. 34 × 16 × 13
Collection of Becky and Jack Benaroya

44. *Ancient Mounds*, ca. 1985
Clay
11 × 16½ × 11½
Collection of Shawn and Cathy Stevens

45. *Ancient Mounds*, 1986 (p. 57)
Bronze
13 × 19 × 10
Collection of Theresa Doherty and Joseph Peterson

46. *Untitled (Cyclops)*, 1988 (p. 63)
Clay
9½ × 17½ × 12
Courtesy of the artist

47. *Off Shore Island*, 1988 (p. 60)
Clay
15¼ × 21½ × 12
Courtesy of the artist

48. *Extended Egg*, ca. 1988
Bronze
8½ × 20 × 11
Collection of Bruce Wick and Carmen Spofford-Wick

49. *Untitled (Sculpture with Hole)*, 1988
Clay
12 × 14 × 11
Collection of Joan and Charles Doan

50. *Klee Moon,* 1988 (p. 64)
 Clay
 24 × 16 × 15
 Collection of Douglas and
 Patricia Ikegami

51. *Eclipse,* 1988
 Clay
 30 × 16 × 9
 Collection of Herb and
 Theresa Goldston

52. *Aerobic Figure,* 1988 (p. 20)
 Clay
 13 × 16 × 14
 Collection of Paul and
 Elaine Von Rosenstiel

53. *Continental Shift II,* 1988 (p. 61)
 Bronze
 16 × 14 × 8
 Private collection

54. *Oval Bud,* 1990
 Clay
 24 × 14 × 10
 Collection of Sue Karahalios

55. *Nutcracker,* ca. 1990 (p. 65)
 Clay
 31 × 13 × 9
 SAFECO, Seattle

56. *Seed,* 1991 (p. 62)
 Bronze
 14 × 16¾ × 8
 Private collection

57. *Keyhole Helmet,* 1991
 Bronze
 19 × 16 × 16
 PACCAR Inc., Seattle

58. *Oval Series with Cleft,* 2001
 (pp. 66, 67)
 Bronze
 36 × 18 × 9
 Collection of Ann Morris

59. *Frost Wedge,* 2001 (p. 21)
 Bronze
 36 × 16 × 8
 Collection of Karin and
 James Webster

60. *Chip Rock,* 2002
 Bronze
 37 × 13 × 8
 Collection of Dins Danielsen

Biography

Born in 1918 in Eureka Township, Michigan

Resides in La Conner, Washington

Education

1938–
1942 Rhode Island School of Design

1990 Honorary B.A., Rhode Island School of Design

One- and Two-Person Exhibitions

1960 *Barbara James and Clayton James,* Miller Pollard, Seattle

1963 *Barbara James and Clayton James,* Reed College, Portland, Oregon

1970 *Clayton James,* Northwest Crafts Center and Gallery, Seattle

1975 *Clayton James: Clay Sculpture and Pottery,* Northwest Crafts Center and Gallery, Seattle

Paul Havas and Clayton James, Nagatani Gallery, Burlington, Washington

1978 *Clayton James: New Works in Clay and Wood,* Northwest Crafts Center and Gallery, Seattle

1981 *Clayton James: Recent Works,* Northwest Crafts Center and Gallery, Seattle

1984 *Clayton James: Clay Sculpture,* Traver Sutton Gallery, Seattle

1985 Nagatani Gallery, Burlington, Washington

1986 *Clayton James: Bronze Sculpture,* Traver Sutton Gallery, Seattle

Clayton James and Ed Nordin, Childers/Proctor Gallery, Langley, Washington

1987 *Clayton James and Ed Nordin,* Childers/Proctor Gallery, Langley, Washington

1988 *Clayton James: Aerobic Figures,* Traver Sutton Gallery, Seattle

Clayton James, Richard Proctor, Childers/Proctor Gallery, Langley, Washington

1990 *Paul Havas, Clayton James,* Janet Huston Gallery, La Conner, Washington

1991 *Clayton James and Joseph Petta,* Gordon Woodside/ John Braseth Gallery, Seattle

1992 *Clayton James: Sculpture, Landscape Transformed,* Valley Museum of Northwest Art, La Conner, Washington

1997 *Rock and River: Clayton James,* Lucia Douglas Gallery, Bellingham, Washington

Clayton James, William Slater, Edison Eye Gallery, Edison, Washington

1999 *Clayton James, Ed Nordin,* Edison Eye Gallery, Edison, Washington

2001 *Clayton James and Dederick Ward,* Edison Eye Gallery, Edison, Washington

2002 *Clayton James and Paul Havas,* Lucia Douglas Gallery, Bellingham, Washington

Clayton James, Museum of Northwest Art, La Conner, Washington

Public Commissions

1984 *Chambered Canyon Walls,* Gov. John R. Rogers High School, Puyallup, Washington

1999 *River Rocks,* Big Rock Garden, Bellingham, Washington

Selected Group Exhibitions

1958 *44th Annual Exhibition of Northwest Artists,* Seattle Art Museum

18th Annual Washington Artists' Exhibition, Tacoma Art League

1960 *46th Annual Exhibition of Northwest Artists,* Seattle Art Museum

1961 *New Northwest Talent,* Tacoma Art League

47th Annual Exhibition of Northwest Artists, Seattle Art Museum

1963 *49th Annual Exhibition of Northwest Artists,* Seattle Art Museum

1967 *Summer Salon,* Henry Art Gallery, University of Washington, Seattle

Anacortes Arts and Crafts Festival, Washington

1974 *Skagit Valley Artists,* Seattle Art Museum

1976 *Works in Wood by Northwest Artists,* Portland Art Museum, Oregon

1978 *Works in Wood,* Visual Arts Resources, University of Oregon Museum of Art, Eugene (traveling exhibition)

1979 *Another Side to Art: Ceramic Sculpture of the Northwest, 1959–1979,* Seattle Art Museum

Northwest Invitational 1979, Whatcom Museum of History and Art, Bellingham, Washington

Fire Arts '79, Bellevue Art Museum, Washington

1980 *Governor's Invitational Exhibition,* State Capitol Museum, Olympia, Washington, and Cheney Cowles Memorial Museum, Spokane

Salon des Refusés 1980, Soames-Dunn Building, Seattle

Ceramic Sculpture Invitational, Whatcom Museum of History and Art, Bellingham, Washington

Skagit Valley Artists, Skagit Valley College, Mount Vernon, Washington

Nagatani Gallery, Burlington, Washington

1981 *Ceramics: 14 Artists,* Foster/White Gallery, Seattle

The Washington Year, A Contemporary View: Embellishment Beyond Function, Henry Art Gallery, University of Washington, Seattle

Nagatani Gallery, Burlington, Washington

1982 *Washington Craft Forms, Creators, and Collectors,* State Capitol Museum, Olympia, Washington

Nagatani Gallery, Burlington, Washington

Northwest Sculpture Exhibition, Whatcom Museum of History and Art, Bellingham, Washington

1983 *Summer Show,* Valley Museum of Northwest Art, La Conner, Washington

Regional Crafts: A Contemporary Perspective, Bellevue Art Museum, Washington

1984 *Clay 1984,* Traver Sutton Gallery, Seattle

Crafts '84, Bellevue Art Museum, Washington

1985 *Nine Ceramic Sculptors: Northwest Show,* Snohomish County Visual Art Center, Everett, Washington

Gardens of Art, Big Rock Garden, Bellingham, Washington

1986 *Summer Harvest,* TRG Wolff Building, La Conner, Washington

Northwest Ceramics Invitational, Eastern Washington University, Cheney

10/40: Anniversary Celebration, Bellevue Art Museum, Washington

Summer Show '86, Valley Museum of Northwest Art, La Conner, Washington

1987 *Bumberbiennale,* Bumbershoot Arts Festival, Seattle Center

1988 *Contemporary Survey: A Visible Presence in the Northwest,* Cheney Cowles Memorial Museum, Spokane

Our Northwest Heritage, Valley Museum of Northwest Art, La Conner, Washington

Clay/Glass, Traver Sutton Gallery, Seattle

1989 *Ceramics Invitational,* Arts Center, Everett, Washington

In Retrospect: Twenty-Five Years, The Governor's Invitational Art Exhibition, Washington State Capitol Museum, Olympia

Washington Crafts: Then and Now, Tacoma Art Museum

Collector's Exchange, Janet Huston Gallery, La Conner, Washington

Fall Exhibition, Nagatani Gallery, Burlington, Washington

1990 *Views and Visions in the Pacific Northwest,* Seattle Art Museum

One Hundred Years of Washington Art, Tacoma Art Museum

Spring Show, Valley Museum of Northwest Art, La Conner, Washington

Opening Show, Viewpoint Gallery, Camano Island, Washington

Mary Randlett: Photographs of Twelve Northwest Artists with Examples of Each Artist's Work, Janet Huston Gallery, La Conner, Washington

1992 *Skagit Valley Artists,* Valley Museum of Northwest Art, La Conner, Washington

A Garden for Sculpture, Bumbershoot Arts Festival, Seattle Center

Honey, I Shrunk the Art, History of the World, Pt. III Gallery, Stanwood, Washington

1993 *Clayton James, Ed Kamuda, Dede Ward,* Edison Eye Gallery, Edison, Washington

Northwest Masters, Gordon Woodside/John Braseth Gallery, Seattle

1994 *Languages of Landscape,* Washington Center for the Performing Arts, Olympia

Selections from the Seafirst Corporate Art Collection: The First 25 Years, Seafirst Gallery, Seattle

Landscapes, Lucia Douglas Gallery, Bellingham, Washington

Cast at Riverdog, Port Angeles Fine Art Center, Washington

1995 *Northwest Art . . . Shaped by the Spirit, Shaped by the Hand,* Museum of Northwest Art, La Conner, Washington

Clayton James, Dederick Ward, Mary Froderberg, Edison Eye Gallery, Edison, Washington

Plein Air, Edison Eye Gallery, Edison, Washington

1996 *Clayton James, Mary Randlett, Paul Havas,* Lucia Douglas Gallery, Bellingham, Washington

Estuary: Clayton James, Bill Slater, Steve Johnson, Edison Eye Gallery, Edison, Washington

1997 *Valley Artists,* Skagit Rose Farms, Mount Vernon, Washington

1998 *Clayton James, Ed Kamuda, Louise Kikuchi,* Edison Eye Gallery, Edison, Washington

A Stew: Eight Sculptors, Edison Eye Gallery, Edison, Washington

1999 *From Here to the Horizon: Artists of the Rural Landscape,* Whatcom Museum of History and Art, Bellingham, Washington

Without Boundaries: Elemental Landscapes, Edison Eye Gallery, Edison, Washington

2000 *Susan Bennerstrom, John Cole, Clayton James, Thomas Wood,* Lucia Douglas Gallery, Bellingham, Washington

Paul Havas, Clayton James, Merle Martinson, Edison Eye Gallery, Edison, Washington

2001 *Clayton James, Dederick Ward, Ed Kamuda,* The Depot Arts Center, Anacortes, Washington

Collections

Bank of America, Seattle

Museum of Northwest Art, La Conner, Washington

PACCAR Inc., Seattle

SAFECO, Seattle

Seattle Art Museum

Stoel Rives LLP, Seattle

Whatcom Museum of History and Art, Bellingham, Washington

Bibliography

Ament, Deloris Tarzan. "Arts Board Honors Cumming." *Seattle Times,* October 11, 1991.

———. "Clayton James: Simplicity and Purity," in *Iridescent Light: The Emergence of Northwest Art.* Seattle: University of Washington Press, 2002.

Campbell, R. M. "Clayton James' Clay Pots." *Seattle Post-Intelligencer,* October 11, 1975.

———. "Clayton James." *Seattle Post-Intelligencer,* May 14, 1978.

Danielsen, Dins. *Clayton James, A Journey* (video), 1997.

Fiege, Gale. "Simple Forms." *Skagit Valley Herald,* October 31, 1985.

Glowen, Ron. "His Art Has Gone to Pots." *Everett Herald,* February 19, 1981.

Hackett, Regina. "Sculpture Show Is James' Best." *Seattle Post-Intelligencer,* February 20, 1981.

———. "An Old Metaphor Gets Some New Curves." *Seattle Post-Intelligencer,* September 17, 1988.

Harrington, La Mar. *Ceramics in the Pacific Northwest.* Seattle: University of Washington Press, 1979.

Kangas, Matthew. "Ceramics by Clayton James." *Seattle Weekly,* May 17, 1978.

Mills, Dale Douglas. "Pacific Northwest Living." *Seattle Times,* March 5, 1978.

Olson, Susan. "Clayton James: Notes on an Ancient Craft." *Seattle Times,* December 30, 1979.

Pumphrey, Ruth. "Studio Takes on the Look of His Sculpture." *Seattle Post-Intelligencer,* January 10, 1982.

Robbins, Tom. *Skagit Valley Artists.* Seattle: Seattle Art Museum, 1974.

Skagit Valley Artists, 1974–1992. La Conner, Wash.: Valley Museum of Northwest Art, 1992.

Spitzer, Rosalind. "Sculpture in the Garden." *The Weekly* (Seattle), June 1986.

Tarzan, Deloris. "The Visual Arts." *Seattle Times,* October 14, 1975.

———. "Ceramic Constructions Akin to Ancient Storage Vessels." *Seattle Times,* February 11, 1981.

———. "Clay Pieces Aren't Just Dust in the Winds of Time." *Seattle Times,* October 12, 1984.

———. "Powerful Art Is Shaped in a Fragile Medium." *Seattle Times,* September 21, 1988.

Voorhees, John. "Sculpture Pleases Eye at Craft Center." *Seattle Times,* September 25, 1970.

Walbeck, Nancy. "Sculptor Clayton James: Form *Is* Content." *Anacortes American,* May 20, 1992.

"Western Washington Potters." *Studio Potter,* December 1981.

Wilson, Adrian. *Two Against the Tide: A Conscientious Objector in World War II, Selected Letters 1941–1948.* Austin, Tex.: W. Thomas Taylor, 1990.

Donors to the Exhibition

Benefactor
Paul Allen Foundation for the Arts

Patrons
Anonymous
Judi and Harry Mullikin
Dederick Ward and Susan Parke
Washington Women's Foundation

Sponsors
Lester and Gloria Abbenhouse
Mary and Tom Moody
Ann Morris
Lynn Hays and Nancy Nordhoff
Babo Olanie
Jim and Bev Shaw
Carmen Spofford and Bruce Wick

Supporters
John and Dorothy Anderson
Ralph and Shirley Anderson
Thomas Bayley
Becky and Jack Benaroya
Betty Black
Sue Karahalios and Steve Brickley
Jim and Phyllis Dunlap
Marshall and Elena Hatch
Albert Heath
Frank Hull
Vern and Jerry Jackson
Gerry Jordheim
John Osberg
Grace Elgian Park
Mary Randlett
Caryl Roman
Seattle Foundation
Chuck Stavig
Robyn and Dan Tracy
The Voss/James family: Glenn, Sherryl, Nicholas,
 Laurance, Pauline, and Paul
Washington State Arts Commission
Ken and Jan Wherry

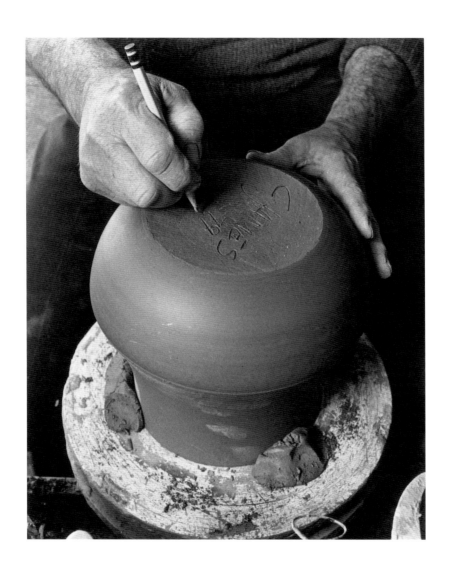